Treasures *from* India

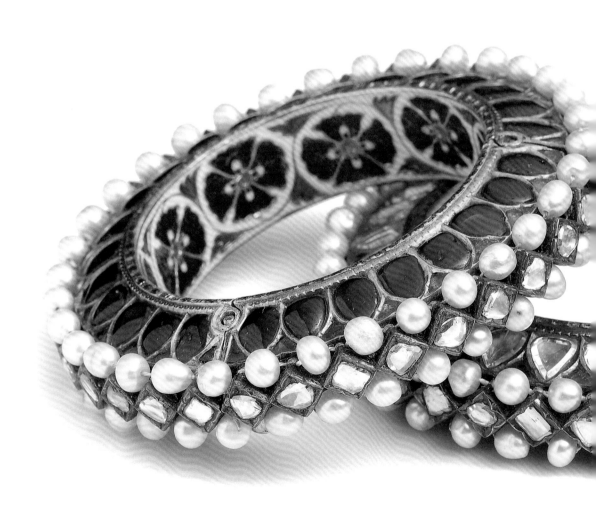

Treasures *from* India

Jewels from the
Al-Thani Collection

NAVINA NAJAT HAIDAR

AND

COURTNEY ANN STEWART

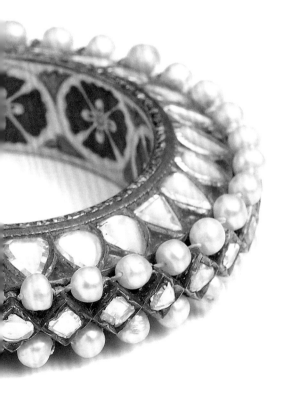

THE METROPOLITAN MUSEUM OF ART, NEW YORK

Distributed by Yale University Press, New Haven and London

This catalogue is published in conjunction with the exhibition "Treasures from India: Jewels from the Al-Thani Collection," on view at The Metropolitan Museum of Art, New York, from October 28, 2014, through January 25, 2015.

The exhibition is made possible by

Cartier

Published by The Metropolitan Museum of Art, New York
Mark Polizzotti, Publisher and Editor in Chief
Gwen Roginsky, Associate Publisher and General Manager of Publications
Peter Antony, Chief Production Manager
Michael Sittenfeld, Managing Editor
Robert Weisberg, Senior Project Manager

Edited by Elisa Urbanelli
Designed by Wilcox Design
Production by Sally VanDevanter
Image acquisitions and permissions by Crystal Dombrow

Typeset in Joanna
Printed on 150 gsm Gardapat Bianka
Separations by Professional Graphics, Inc., Rockford, Illinois
Printed and bound by Graphicom S.r.l., Vicenza, Italy

Photographs of works in the Metropolitan Museum's collection are by The Photograph Studio, The Metropolitan Museum of Art, unless otherwise noted. Additional photography credits appear on page 144.

Jacket illustration: *Base of a Water Pipe*, 1740–80 (p. 38); pp. 2–3: *Pair of Bangles*, ca. 1775–1825 (p. 71); p. 5: detail of *Flask*, 1650–1700 (p. 32); p. 10: detail of *Necklace*, 1850–75 (p. 87); p. 24: detail of *Dagger with European Head*, ca. 1620–25 (p. 26); p. 40: *Finial from the Throne of Tipu Sultan*, ca. 1790 (p. 47); p. 56: detail of *Turban Ornament*, 1825–75 (p. 64); p. 96: detail of *Cartier Emerald Brooch*, 1925/1927 (p. 107, top); p. 114: detail of *Pair of Bangles*, 2012 (p. 122)

The Metropolitan Museum of Art
1000 Fifth Avenue
New York, New York 10028
metmuseum.org

Distributed by
Yale University Press, New Haven and London
yalebooks.com/art
yalebooks.co.uk

Cataloguing-in-Publication Data is available from the Library of Congress.
ISBN 978-1-58839-555-9 (The Metropolitan Museum of Art)
ISBN 978-0-300-20887-0 (Yale University Press)

CONTENTS

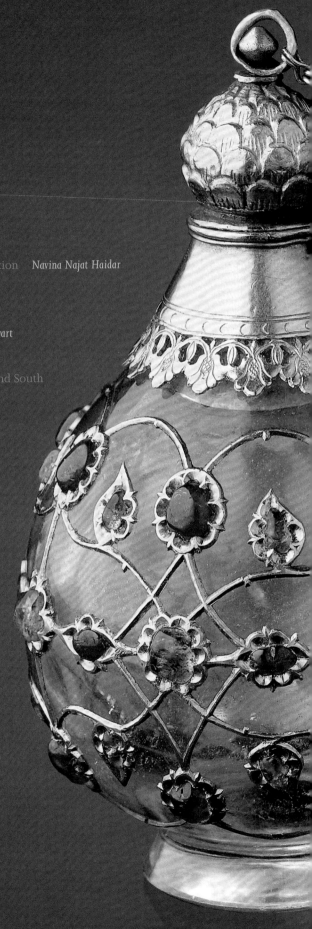

SPONSOR'S STATEMENT

Cartier is honored to sponsor "Treasures from India: Jewels from the Al-Thani Collection" at The Metropolitan Museum of Art and is especially proud that the exhibition includes nine incredible Cartier Indian jewels and turban ornaments that are now part of the private collection of the Al-Thani family and illustrate the Maison's rich history with India.

The story begins in 1911 when Jacques Cartier first traveled to India. The Indian maharajas opened their doors to Cartier, entrusting the firm with their family treasures and placing orders for their most stunning sets of jewelry. While the maharajas had Cartier reset their gold jewelry into the styles of the day, Cartier also took an interest in Indian jewelry traditions and created a new fashion for Indian style with which the West was clearly infatuated, above all for the splendor of the stones—the Kashmir sapphires, Burmese rubies, and wonderful Mughal engraved emeralds.

Many magnificent jewels were commissioned during the illustrious patronage throughout the princely houses of India. More than jeweler and customer, Cartier and the maharajas became trusted friends. It is this trust that resulted in the spectacular jewels that were crafted at that time. India and its beautiful icons continue to lend their grace to Cartier designs—the exotic world is at the very heart of Cartier.

Founded in 1847, Cartier is one of the world's most esteemed jewelry houses, designing and manufacturing exclusive collections of fine jewelry, wristwatches, and prestige accessories. As a "citizen of the world," Cartier is also present on all continents, committed to promoting contemporary art through the Cartier Foundation for Contemporary Art and an initiator of ethical standards in the jewelry industry as a founding member of the Responsible Jewellery Council. Cartier is proud of its longstanding relationship with The Metropolitan Museum of Art, which presented the retrospective "Cartier 1900–1939" in 1997 in conjunction with the firm's 150th anniversary.

Cartier would like to express its gratitude to The Metropolitan Museum of Art for organizing this exhibition and to extend a special thanks to His Highness Sheikh Hamad bin Abdullah Al-Thani for sharing this precious collection. Cartier hopes visitors enjoy this extraordinary journey through the evolving styles of the jeweled arts in India from the Mughal period to the present day.

Stanislas de Quercize
President and CEO
Cartier International

DIRECTOR'S FOREWORD

A shared love of art unites museums and private collectors. Works of art bring not only individuals and institutions into conversation but also whole cultures. This is the story of the Al-Thani collection of jeweled treasures from India, which we are pleased to present at The Metropolitan Museum of Art. Its diverse holdings span four hundred years and trace the changing styles and tastes in jewelry made for Indian royalty, from traditional forms of the Mughal age to Western-influenced creations. The historic and geographic scope of the Al-Thani collection sits well with the universality of the Museum's holdings.

The jeweled arts have an undeniable allure and are perhaps most opulently expressed in the ornaments of India. In the hands of Indian craftsmen, precious gemstones, jade, and gold were forged into adornments for the body as well as luxury objects. The royal courts of India—those of the Mughal rulers and Deccan sultans in the seventeenth century and at Hyderabad, Jaipur, and other centers in the following era—bred patrons of the highest order. Like the Indian elite, the West too loved this art, discovering and reinterpreting it over the centuries. One particularly significant moment of interaction was the early twentieth century, when Western jewelers were engaged by Indian royalty. But this was no ordinary business relationship. A mutual appreciation and exchange of styles, forms, and techniques evolved, giving rise to some of the spectacular works in this exhibition. Underpinning this jeweled efflorescence was a cultural conversation between far-flung traditions that continues to the present day. The contemporary works in the Al-Thani collection attest to that ongoing story.

I take this opportunity to thank His Highness Sheikh Hamad bin Abdullah Al-Thani for generously sharing this collection with The Metropolitan Museum of Art. This collection, impressively built in less than five years, is filled with the energy of its youth and the promise of its future. The Met is pleased to present highlights from the Al-Thani collection in this volume and the exhibition that it accompanies. Special acknowledgment goes to Cartier for its historic role in creating some of the works on display and its present role in supporting the exhibition at the Museum.

Thomas P. Campbell
Director
The Metropolitan Museum of Art

INTRODUCTION

SHEILA R. CANBY

Indian gems have held the world in their thrall for centuries. The only source of diamonds in the world until the eighteenth century, Indian soil also disgorged other gems and gold, highly refined and worked with amazing variety and ingenuity. With the Mughal conquest of northern India in the sixteenth century, a dynastic tradition of hardstone carving and gem setting was established in parallel to the preexisting jewelry arts of the Deccan and southern India. As Mughal power waned in the eighteenth century, the rulers of the Rajput courts and Hyderabad in the Deccan gained wealth and indulged their taste for jeweled weapons and ornaments to wear on turbans, belts, and sleeves. Soon the British recognized that, although the wealth of their Indian princely subjects may have derived from trade in spices and textiles, it was invested in gold, gems, and jade. While the Koh-i-noor may be the most famous Indian diamond to enter the British royal treasury, spinels inscribed with the names of Mughal emperors and booty from the defeat of Tipu Sultan in 1799 all made their way to Great Britain. Some of the greatest Indian diamonds, including the Koh-i-noor, were set into the crowns and tiaras of the British royalty and nobility. By the early twentieth century famous European jewelers such as Cartier not only set Indian gems in jewelry made for European clients but also made pieces to order for Indian patrons, exemplifying a resurgent internationalism that, despite all the political upheaval of the past hundred years, is still thriving today.

The Al-Thani collection of Indian jewelry exists in the centuries-old continuum of princely treasuries holding precious stones and jeweled items. Created

primarily in the twenty-first century, this is a family collection that reflects the passionate interest of Sheikh Hamad bin Abdullah Al-Thani. Like any new collector, Sheikh Hamad has honed his taste with each acquisition, pouncing on rare pieces as they have come available. Additionally he has commissioned modern jewelers to create new works set with Indian gems. One of the great strengths of this collection, well represented in this exhibition, is the range of late eighteenth-, nineteenth-, and twentieth-century jeweled objects. From enameled sword hilts set with gems to two types of turban ornaments known as the *sarpesh* and the *jigha*, this part of the collection reflects the extravagant taste of the maharajas and nizams of India in the period of British suzerainty.

Unlike sculpture and paintings, jewelry, by virtue of its scale and wearability, invites handling, turning it in one's hands to catch the light or running one's finger over a smooth enameled surface. This personal, tactile quality certainly is one of the joys of collecting Indian jewelry. The combination of luxury, intimacy, and history underlies the allure of the Al-Thani collection. The Metropolitan Museum of Art is fortunate, indeed, that the collection's owners have agreed to place this selection of dazzling jewelry on view in proximity to its display of Later South Asian art. This context not only reinforces the visitor's understanding of one aspect of artistic exchange between India and Europe from 1600 to the present day but also highlights the enduring imagination and skill of India's jewelers.

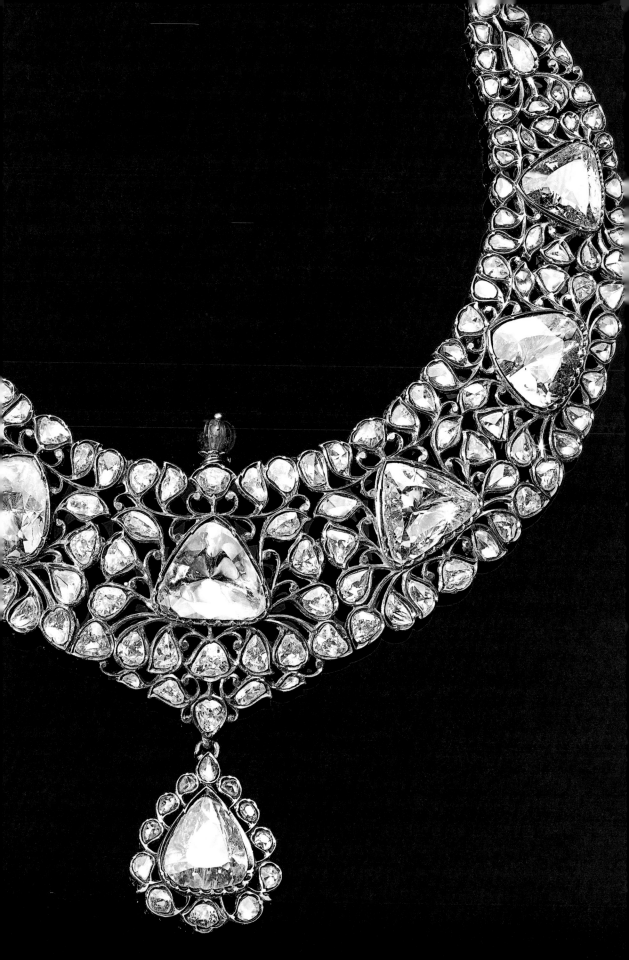

JEWELS *of* INDIA
IN THE AL-THANI COLLECTION

NAVINA NAJAT HAIDAR

India's love of precious ornaments is expressed in her rich heritage of jeweled arts
from court, temple, and household. Indian jewelry styles range from opulent
creations covering almost every visible part of the body to simple amulets worn
around the neck on a cotton string. Although most surviving jeweled objects
date from the late sixteenth century and later, there is ample indication from
Indian sculpture and textual sources that the jeweled arts occupied high status
from earlier times (fig. 1). Within the context of India's princely world, gems
and jewels for the ruling nobility magnified royal glory and enhanced the prestige
of the court. Functional and ceremonial court objects—including boxes, bottles,
daggers, and thrones—were also created from precious materials such as gold,
ivory, and jade and decorated with gemstones and enamel.

 Indian jewelry traditions have remained dynamic, while at the same
time preserving a remarkable sense of continuity from the past. Perhaps most

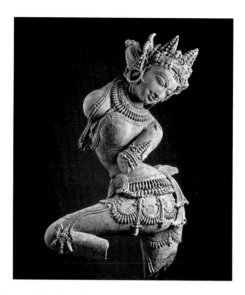

Fig. 1. *Bejeweled Celestial Dancer.* India, Uttar Pradesh, early 12th century. Sandstone, H. 33 ½ in. (85.1 cm). The Metropolitan Museum of Art, Promised Gift of Florence and Herbert Irving (L.1993.88.2)

enduring are the symbolic, talismanic, and auspicious associations of gems and jewelry forms, which still hold a powerful grip on the imagination.

While the spell of India's jewels falls widely, the making of a fine private collection remains a rare achievement. The Al-Thani holdings represent a collector's fascination with works created over a period of four hundred years for Indian royalty, including the imperial Mughals (1526–1858), the nizams of Hyderabad (1724–1948), and the maharajas of the Rajput courts (the eighteenth to the twentieth century), as well as jewelry representing a broader international taste, as seen in the Indian-inspired, twentieth-century works created by Cartier and other Western jewelers under the patronage of the maharajas. The collector, whose initial interest lay in the field of European decorative arts, was drawn to Indian jeweled arts after visiting the exhibition "Maharaja: The Splendour of India's Royal Courts" at the Victoria and Albert Museum, London, in 2009. Soon thereafter, in 2010, he acquired his first piece. From that foundation the collection now holds more than 250 objects representing different traditions and spanning four centuries. Drawn from the larger holdings, the sixty-three works selected for this exhibition and book include a small number of Indian courtly objects of the seventeenth and eighteenth centuries and a larger group

of gems and jewels that reflect exchanges between India and the West after 1800. These latter works are possibly the most novel aspect of the collection.

The Al-Thani collection has been published recently in a substantial volume titled *Beyond Extravagance: A Royal Collection of Gems and Jewels.*[1] A team consisting of Amin Jaffer (editor), Vivienne Becker, Jack Ogden, Katherine Prior, Judy Rudoe, Robert Skelton, Michael Spink, and Stephen Vernoit provided individual descriptions of the objects, contextualizing essays, and technical data. Much of the content within this present volume is drawn from their work, although in some cases descriptions and attributions have been altered to reflect current Museum opinion.

The objects showcased in this book and exhibition are organized into five sections, aiming to present a varied group of highlights by style and chronology. The sections are: 1. Mughal and Mughal-style objects in jade and hardstone, including an important imperial dagger with a European head hilt; 2. gold gem-set objects from the courts of north and south India, including a tiger's-head finial from the throne of Tipu Sultan; 3. examples of traditional Indian jewelry for men and women from various courts and centers of the eighteenth and nineteenth centuries, successors to the Mughal tradition; 4. later Western and Indian jewelry, including pieces by Cartier; and 5. contemporary works made for the collector.

Chosen for both their historical significance and their visual interest, the objects represent a range of periods and styles, recording the story of cross-cultural influences over time. They also demonstrate the changing tastes in Indian jewelry through the setting and resetting of gems, tracing that process from the adaptation of Indian carved emeralds by Cartier to the fashioning of contemporary pieces by Viren Bhagat and JAR (Joel Arthur Rosenthal).

HISTORICAL TRADITIONS OF COURTLY JEWELRY The grandeur of the Mughal imperial vision and the rulers' personal appreciation of gems and jewels are generally acknowledged as critical factors in the development of the jeweled arts in seventeenth-century courtly India. The Mughals' Timurid ancestry provided a taste for certain elements, such as jade and inscribed spinels; however, it was their encounter with existing Indian traditions that led them to fully embrace the

jeweled arts at court. This confluence of traditions brought about a lavish era under Mughal patronage, which led to the establishment of styles and forms that lasted for many centuries. In turn, these developments influenced the tastes and patronage of later maharajas, nawabs, and nizams within the Indian subcontinent and Persians, Ottomans, Arabs, and Europeans beyond India's shores.

Executed in white marble inlaid with semiprecious stones, the Taj Mahal tomb complex, completed by Shah Jahan (r. 1628–58) for his queen about 1653, epitomizes the Mughal vision and aesthetic, particularly under the emperors Jahangir (r. 1605–27) and Shah Jahan. However, alongside their opulence, Mughal jeweled arts also display a great degree of restraint and refinement, as exemplified by a delicate figural dagger in the Al-Thani collection (pp. 26–27). This imperial work has a jade hilt (ca. 1620–25) carved with the head of a youth, possibly copied from a Goan ivory of Christ as the Good Shepherd. It has been noted that the "snail shell" curls of the hair are of Renaissance inspiration, suggesting the hand of a European lapidary at the Mughal court.[2]

Very little jeweled art survives from the sultanate courts of the south-central Deccan plateau, which fell to Mughal domination at the end of the seventeenth century, despite the fact that these courts had yielded enormous wealth, as demonstrated by representations of jewelry in Deccan painting and sculpture, the abundance of diamonds in the region, and descriptions of extraordinary objects. Among the latter is the legendary turquoise throne of the Bahmanids (1347–1538). According to the historian Muhammad Qasim Firishta (1560–1620), it was finished in ebony and featured gold plates studded with jewels and turquoise-colored enameling (a notably early reference to such a technique), the work of Telugu craftsmen in 1361.[3] Some of what we surmise today of earlier Deccan jewelry comes from the later traditions of the nizams' court in Hyderabad. The nizams inherited much of what remained in the Deccan after Mughal conquest and launched an outstanding phase of patronage and creativity in the jeweled arts, characterized by a combination of Deccan and Mughal styles and tastes, which flourished until the twentieth century (pp. 62–63).

Mughal imperial wealth invited much unwanted attention and foreign attack. The raid of the Persian invader Nadir Shah in 1739, while delivering a

short political blow, marked much more lasting damage to the imperial coffers, as treasures, including the jeweled "Peacock Throne," were taken to Iran in large numbers. Some can still be seen in the vaults of the Bank Markazi in Tehran, and others, which made their way to the Russian state, now lie in treasuries in Saint Petersburg and Moscow.[4] With further Afghan invasions in the late eighteenth century and the growing strength of the British Raj (1858–1947), the Mughal, Sikh, and other treasuries eventually succumbed; one of India's greatest gems, the Koh-i-noor diamond, is now the centerpiece of the British crown jewels.[5]

Beyond the imperial Mughal realm, the eighteenth century saw an efflorescence of artistic tradition at diverse courts, under the rule of various largely Hindu maharajas all over Rajasthan, the Punjab hills, and central India, and under Muslim nawabs and rajas in important Mughal successor states such as Lucknow and Murshidabad.[6] These kingdoms, more than five hundred in number and dotted with forts and palaces, came under Mughal political and cultural sway but were also semi-independent, each with its own distinctive traditions, lineage, and tastes. Several forms of jewelry worn by the nobility at these courts, such as the turban ornaments known as the *sarpesh* and *jigha*, are represented in the Al-Thani collection (pp. 58–67, 91–93). The majority of the eighteenth-century pieces gathered here come from Rajasthan, Lucknow, Varanasi, Hyderabad, and Lahore.

Tipu Sultan (r. 1782–99), the "Tiger of Mysore" and a sworn enemy of the British, whose colonial ambitions he predicted and resisted through alliance with the French, left a number of notable jeweled objects from his reign in south India. In the aftermath of Tipu's death at the storming of Seringapatam, his famous octagonal throne was dismantled, and the lifesize gold tiger's head and paws from the base of the throne and the large jeweled *huma* (a Persian mythical bird of power or kingship) that surmounted the canopy now lie in the Royal Collection at Windsor Castle (figs. 2, 3).[7] Other parts of the throne are dispersed elsewhere; the tiger's-head finial in the Al-Thani collection (pp. 46–47), one of eight gem-set mounts, is from the surrounding railing. A faceted gold "magic box," also from Tipu's time, opens up into different combinations of mathematical numbers and formulas (p. 48). In his *khwabnama* (book of dreams), the

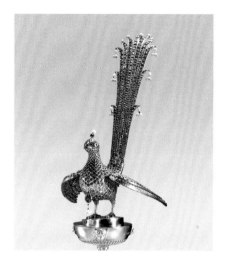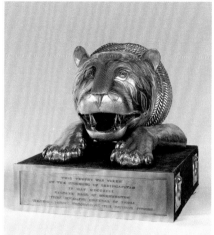

Fig 2. Huma *Bird from the Canopy of Tipu Sultan's Throne*. India, Mysore, ca. 1787–91. Gold, set with rubies, emeralds, diamonds, and pearls; silver gilt, H. 16 1/2 in. (42 cm), W. 7 7/8 in. (20 cm), D. 11 1/8 in. (28 cm). Royal Collection Trust (RCIN 48482)

Fig. 3. *Tiger's Head and Paws from Tipu Sultan's Throne*. India, 1740–99. Gold, set with rubies, diamonds, and rock crystal, H. 18 1/8 in. (46 cm), W. 22 1/2 in. (57 cm), D. 18 7/8 in. (48 cm). Royal Collection Trust (RCIN 67212)

mystically oriented Tipu recorded a dream of receiving large emeralds, an indication of the hold that gems had on this Indian ruler's subconscious.[8]

Mention has been made of the Hyderabad kingdom of the Asaf Jah dynasty (1724–1948), but it is perhaps worth noting that this was possibly the richest Islamic state of its time, and when annexed into the Union of India in 1948, its coffers formed the financial backbone of that new state. In 1972 a large selection of the nizam of Hyderabad's jewels, including the Jacob Diamond from South Africa, was offered to the Indian government, which finally took possession of it in 1995.[9] Additional treasures from Hyderabad were dispersed into other collections, including this one. A diamond necklace in the Al-Thani collection (pp. 86–87) is among the strikingly lavish works made for the ruling family in the late nineteenth century. As with all Indian jewelry, today it must be understood in relation to the rich costumes and textiles of the times, and imagined worn within the setting of the late palaces and gardens of Hyderabad.

Western influence on the jeweled arts came to India's maharajas in various forms. The nineteenth and twentieth centuries saw the fascinating transformation of old styles using new techniques and the creation of new forms

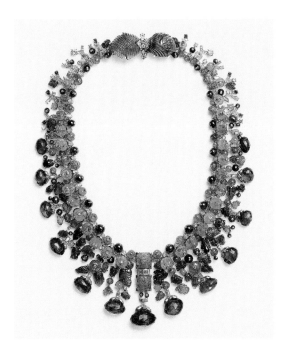

Fig. 4. *"Hindu" Necklace*. France, Paris, made by Cartier, 1936; altered 1963. Platinum, white gold, diamonds, sapphires, emeralds, and rubies, L. 17 in. (43.2 cm). The Cartier Collection

using traditional methods. By the time Jacques Cartier made his fruitful 1911 trip to India, many royal clients had already patronized Western jewelers or commissioned westernized works from Indian jewelers. Cartier's visit, on the occasion of the Coronation Durbar in honor of King George V and Queen Mary, exposed him to a new world of jewelry making and brought him royal clients. He was entrusted with remounting older stones in new settings, frequently in platinum, in keeping with the newfound appreciation for Western-style, highly faceted and polished stones. He also saw the older Indian manner in which gems were carved with motifs and their color enhanced by foils, later inspiring the bright colors of his famous "Hindu" ("Tutti Frutti") necklace of 1936 (fig. 4), among other exotic Cartier works of the 1920s and 1930s. Possibly the most opulent Cartier commission during this period was the Maharaja of Patiala Necklace of 1928, a multiple-stranded extravagance with many large diamonds, including the 234.69-carat De Beers Diamond.[10] An exhibition at The Metropolitan Museum of Art in 1997 and its accompanying catalogue explored the subject of Cartier jewelry from 1900 to 1939, discussing the firm's developments in these impor-

tant years and its venture into various foreign styles.[11] The Al-Thani collection has several works dating from this phase of Cartier's production, including two large carved emeralds, one from a celebrated neck ornament known as the Collier Bérénice and the other from a related brooch (pp. 106–107).

Although the nineteenth and twentieth centuries witnessed changes in taste and the adoption of westernized styles and techniques, traditional Indian types of jewelry continued to be produced at centers such as Jaipur, Ahmadabad, and Varanasi, among others. The quality of workmanship remained high enough that scholars today often debate whether an object in the Mughal style belongs to its perceived historical period, the nineteenth century, or an even more recent era. Caution generally dictates later dates for the scholar, but it is important to acknowledge the possibility that an object thought to have been made in nineteenth-century Jaipur may have been made there or perhaps in Agra or Delhi at an earlier time.

India today continues to be a vibrant center for the jeweled arts. While the traditions of the jeweled object largely gave way during the nineteenth century, those of the jeweled body endure in force. Among other places, Jaipur remains a major center for the gem trade and jewelry production, Hyderabad for pearls, and Bombay and Gujarat for the diamond industry. The present day is also experiencing the rise of new jewelry design, as exemplified by the contemporary works in the Al-Thani collection. A pendant brooch by the Bombay-based jeweler Viren Bhagat reuses older Indian gems in a new setting (p. 121), while a brooch by the Paris-based jeweler JAR demonstrates the ongoing exchange between Indian and Western forms (p. 116).

MATERIALS AND THEIR SOURCES India was and remains one of the world's largest consumers of gold and gemstones. It also has been the source of some of the world's greatest gems, particularly diamonds. The international trade in gold had been well established since antiquity and continued to provide the precious metal in the later period, supplemented with local gold from alluvial mines in places such as Kollur, in modern-day Karnataka. A gold horde discovered in 2011 at the Padmanabhaswamy temple in Kerala, valued at many billions

of U.S. dollars and reputed to contain objects such as a gold bathtub weighing forty kilograms, is indicative of the status and importance of the precious yellow metal in India.[12] In the seventeenth century gold was the material chosen almost exclusively for jewelry settings, but from the late eighteenth century onward a vogue for white metals such as silver and platinum, and even pewter in the Victorian period, was established. This transition in taste can be seen in the objects gathered here.

In premodern times the area around Golconda in the Deccan was the main source for diamonds, famed for their pale pink color, as seen in the Koh-i-noor diamond, but also occurring in yellow-white and shades of green and blue.[13] Mining, shaping, polishing, and inscribing gems became areas of technical achievement; even today India's diamond industry is one of the world's largest.[14] However, the traditional Indian taste was not for highly cut and faceted stones, but rather for cabochon-style gems or those with very subtle facets. Other varieties of gemstones came into India from farther afield: emeralds, which until the twentieth century were typically carved with floral motifs, were imported mostly from Colombia and possibly elsewhere; spinels, which were sometimes inscribed with royal titles or simply polished and threaded as pendants, were sourced from the Mughal ancestral home of Badakhshan in Afghanistan; and rubies and sapphires, the latter appearing especially in twentieth-century jewelry, originated in Sri Lanka and Burma. Pearls made their way from the Persian Gulf, the most favored source for the eighteenth-century Hyderabad court, and were also found locally.

Hardstones were carved to form the bodies of objects and then inlaid with gold and gems, or they were inserted as plaques into jewelry. Like gemstones, they were sourced in a variety of places. Nephrite jade, in shades ranging from pale white to dark green, came from Chinese Central Asia; beginning in the eighteenth century, jadeite, another variety, was obtained from Burma. Rock crystal and other hardstones were sent from Afghanistan and parts of the Himalayas.

TECHNIQUES AND STYLES The publication *Beyond Extravagance* describes the various techniques applied in producing Indian jewelry, including those used

to create objects in the Al-Thani collection; some were unique to the subconti-
nent, and others were the result of foreign contact.[15] The art of enameling, for
example, may have come into India through foreign jewelers in the Mughal period
or earlier, or it may have developed independently in the Deccan; once established,
it took on regional styles and colors.[16] Historically, workshops were relatively sim-
ple spaces, and craftsmen rarely signed their pieces. However, in recent times, the
names of contemporary jewelers and designers have become better known.

The most distinctively Indian style of gem setting is the *kundan* technique,
in which highly purified gold, soft and malleable at twenty-two to twenty-four
karats, is pressed around gems to hold them in place without claws or prongs,
allowing entire surfaces to be covered or inlaid. The gems are set into foiled
beds that serve to intensify their colors through the reflection of light penetrating
the stones. In the late nineteenth and early twentieth centuries even faceted
gems were often set using this traditional method, although by this time a vari-
ety of Western features such as claws, prongs, and openwork wire frames had
also been adopted (p. 66).

A technically advanced area was the carving of jade, a material famous
for its extreme resistance. The Mughal love of natural forms marked by soft,
curving lines—as opposed to the straighter and stiffer elements of the Timurid
and Chinese traditions—challenged Indian carvers to reach great heights in
applying their technical prowess to this unyielding hardstone. European lapidaries
at the Mughal court in the first half of the seventeenth century may have also
contributed to this development.

New understanding about wider traditions of eighteenth-century jade
carving has led to a fresh appreciation for the nonimperial sources of jade
production that existed beyond the Mughal centers of Agra and Delhi, at places
such as Lucknow.[17] The Metropolitan Museum recently put on view a collection
of Mughal-style jade bowls from the 1902 bequest of Heber R. Bishop, two on
their original wooden stands from the Beijing palace and one containing verses
by the Qing ruler Qianlong (1711–1799) describing "Hindustan" (fig. 5).[18]
While the vessels have the natural curving bodies seen in Mughal jades of the
seventeenth century, their angular handles, with stiffly realized buds and leaves,

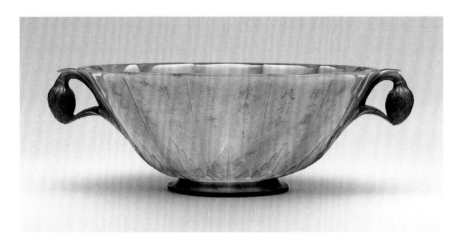

Fig. 5. *Bowl in the Shape of a Chrysanthemum Flower.* India, 18th century. Inscribed with verses in Chinese. Jade (nephrite), H. 2⅝ in. (6.7 cm), Diam. 6¾ in. (17.1 cm). The Metropolitan Museum of Art, Gift of Heber R. Bishop, 1902 (02.18.762)

indicate that the objects were not likely made in India. This evidence, together with similar material in the National Palace Museum, Taipei, and other examples elsewhere, suggests that Chinese Central Asia was the likely place where these Mughal-style jades were carved in the late eighteenth century, as tribute for Beijing.[19] Emperor Qianlong's idea of Hindustan, mentioned in his poems, may have corresponded to the much-admired tradition and style of the carving rather than to the place itself.

Among the objects in the Al-Thani collection, an inlaid jade *huqqa* base attributed to the late eighteenth century is associated with the Delhi Durbar of 1903, one of the era's most glittering assemblies of royal splendor, where it was likely presented by the maharana of Udaipur (p. 38).[20] It demonstrates that the jade carving continuing in eighteenth-century India was of high quality and pre-served a taste for allover arabesque designs that had developed a century or more earlier. A further revival in nineteenth-century Jaipur took the art of jade carving to its final expression.

Growing contact with the West during the British Raj brought many new techniques to the jeweled arts. Gem faceting, prong settings, and new materials have already been mentioned. To those we can add styles of chain link and methods of enameling, framing, and carving that were previously unknown in India.

FORMS AND MEANING Worn on the body of an Indian king or ruler, jewelry enhanced both worldly power and divine association. Dynastic lineage, too, was marked through the engraving of titles and dates into spinels and other gems. The Shah Diamond in the Kremlin Museum, with its date of 1591, corresponds not only to the accession of Burhan Nizam Shah II (r. 1591–95) to the Ahmadnagar throne but also to the one-thousandth year of Islam, possibly making it the only known millennial diamond (fig. 6).[21]

The dressing of the head was an important part of the presentation of the royal Indian prince. In particular, the *sarpesh*, or jeweled head ornament, complete with a *jigha*, or aigrette, had an interesting development. Originating with the Mongol ancestors of the Mughals as a plume of owl feathers, the ornament was adapted in India, where the emperor wore egret feathers, weighed down by pearls, in his turban. This plume was also realized in jeweled form, possibly inspired by European aigrettes, which were known at court and were given out to nobles as symbols of princely recognition. Examples of headpieces in the Al-Thani collection trace their development from more traditional profiles to Europeanized ones (pp. 58–67, 91–93, 98–99, 110–112). A Nepalese crown in the shape of a turban, complete with its attached *sarpesh*, brings together the entire convention for dressing the male head (pp. 94–95).

On the female body, beauty, power, virtue, role, and status were all expressed through the choice of specific jeweled forms. Wedding ceremonies, religious festivals, and courtly durbars or gatherings were occasions for which jewelry was worn or commissioned. Even royal animals were bedecked with ornaments particular to them. So well developed are the individual types of wedding jewelry that in one charming hill tradition each jeweled shape is precisely reproduced in ornaments of fresh flowers (*phoolon ke gehne*) for village brides.[22] The Al-Thani collection includes some traditional forms associated with women: the bangle (*kada*; p. 71), the forehead ornament (*tika*; pp. 74–75), the anklet (*paijeb*; pp. 68, 70), and the nose ring (*nath*; p. 76).

Objects made for the court often had symbolic meaning. The jade fly whisk holder of about 1700 (pp. 34–35), for example, is an implement used in an ancient practice of honor, employed in early Hindu and Buddhist

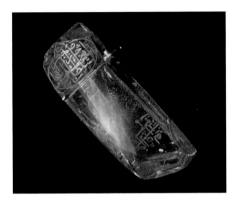

Fig. 6. *The Shah Diamond.* Inscribed "Burhan Nizam Shah. Year [A.H.] 1000 [A.D. 1591]," "Son of Jahangir, Shah Jahan. Year [A.H.] 1051 [A.D. 1641]," "Sultan Qajar Fath Ali Shah. Year [A.H.] 1242 [A.D. 1824]." State Diamond Fund, Armoury Chamber, Kremlin Museum, Moscow

imagery and adopted by the Mughals, in which a yak's-tail whisk or other plume was inserted into the top of the jade handle and waved above a noble or divine figure.

Gems, too, have long had metaphorical associations, as they are imbued with medical qualities, color allegories, and celestial symbolism, the latter particularly expressed in the *navaratna*, or nine-gem combination, representing the planets.[23] While diamonds, emeralds, and rubies were commonly used in traditional jewelry, blue sapphires have been much less prevalent, owing to their ambiguous role. The blue gem is associated with the planet Saturn, which is thought to sometimes exert a negative influence. Gem dealers in India today reputedly allow clients to sleep with a sapphire under their pillows for three nights, and if any inauspicious signs occur, they will readily take it back. Whether this bias against the gem goes back to courtly times is not clear, but certainly the appearance of a sapphire as the centerpiece of a magnificent turban ornament of about 1920 (p. 91) is a rarity.

The Al-Thani collection is still growing, with an eye toward acquiring both old and new works. The collector's pursuit of contemporary jewelry reflects the ancient relationship between patron and artist, one that has given rise to extraordinary works in the past and will endure into the future, as royal taste continues to inspire the art of the jeweler.

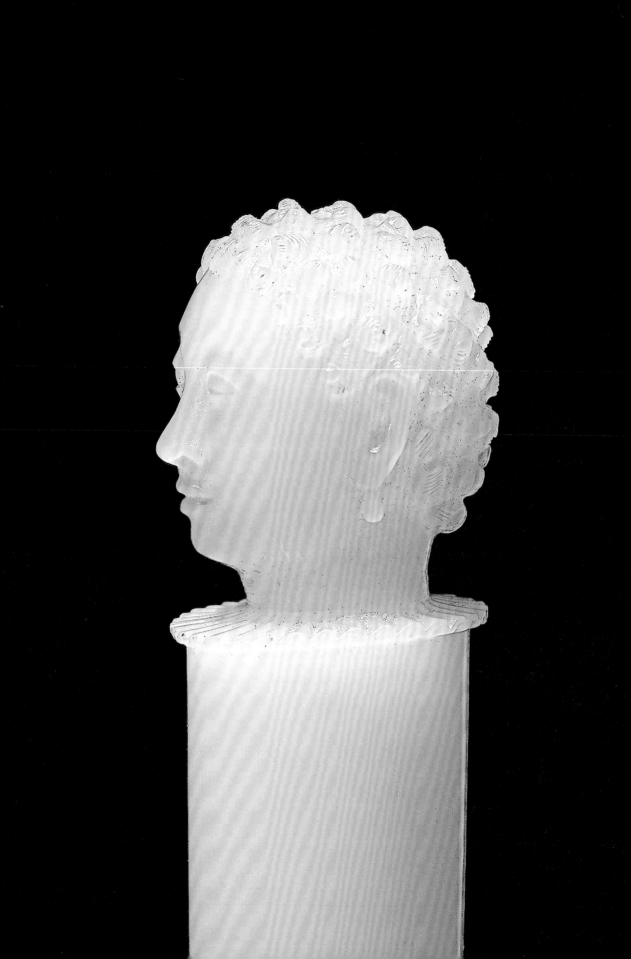

REFINEMENTS *in* JADE
and HARDSTONE

Nephrite jade, which originates in the area of Khotan, in Chinese Central Asia, occurs in a range of colors, from a dense, almost black shade of green to pale, luminescent white. Mughal rulers inherited a taste for this precious material from their Timurid ancestors. The Mughal love of natural forms in art challenged seventeenth-century craftsmen to shape jade and other hardstones into softly curving profiles that were inspired by closely observed flowers, plants, and animals. Jade objects such as dagger handles, vessels, and ornaments were often enhanced with inlays of gold scrolls or flowers and precious gems.

Beyond the Mughal realm, the patronage for the production of jade objects took place at other centers, mainly in north India, and lasted into the nineteenth century, developing further forms. Boxes, bowls, and smoking apparatus of inlaid jade in a variety of shapes and styles appear in paintings as part of a courtly environment, along with luxury textiles and other opulent objects. This selection from the Al-Thani collection traces jade carving from a seventeenth-century Mughal dagger with a delicately rendered human head as the hilt to later courtly objects made from the same material.

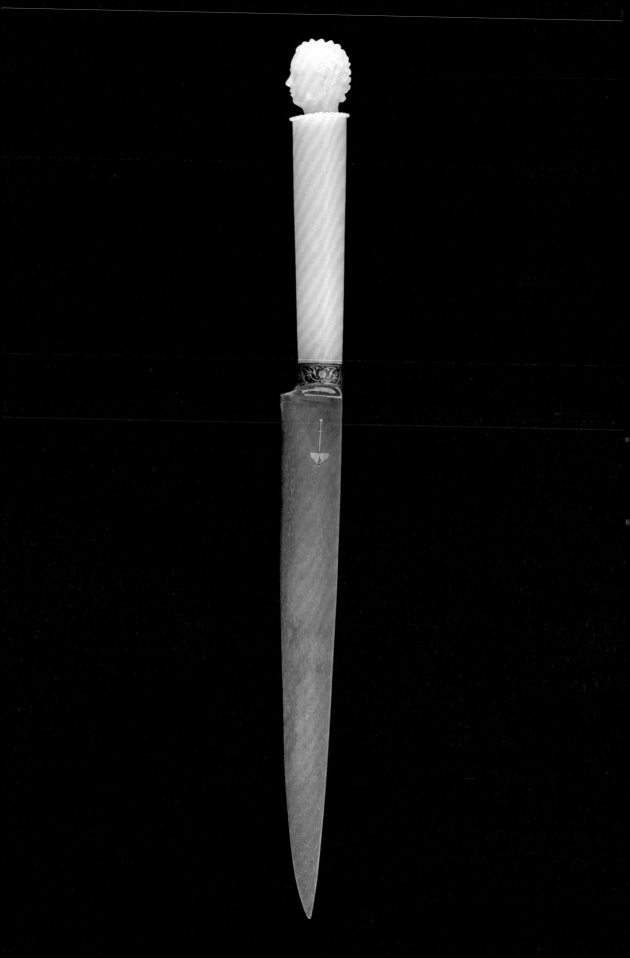

DAGGER (*KARD*) WITH EUROPEAN HEAD

North India, Mughal, ca. 1620–25 (hilt), 1629–36 (blade)

Watered steel blade, inlaid with gold; jade hilt

L. (overall) 11 3/4 in. (29.7 cm), L. (jade hilt) 4 3/8 in. (11.1 cm)

Inscribed: *sahib-i qiran sani 2* (Second Lord of the Conjunction, regnal year 2, or possibly 9)

A portrait of Emperor Jahangir (r. 1605–27) wearing a small, straight dagger (*kard*) ornamented with a human head has led scholars to attribute the carving of this jade hilt to his period. The blade bears the title and reign dates of his son and successor, Shah Jahan (r. 1628–58), suggesting that the dagger was later reworked for him.[1] Gold inlay on the blade includes floral scrolls and quatrefoils, as well as two Mughal symbols, the royal umbrella (*chattri*) and the auspicious fish (*mahi*). The European youth's head on the hilt of this dagger might have been copied from a Goan ivory of Christ as the Good Shepherd.[2] The carving may be the work of a European lapidary at the Mughal court.

This object was reputedly in the collection of Samuel F. B. Morse, the inventor of the Morse code.

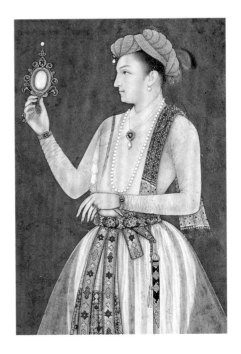

Prince Salim (later Emperor Jahangir) wears a dagger with a human-headed hilt. Detail of *Prince Salim*, by Bichitr, Mughal, ca. 1630

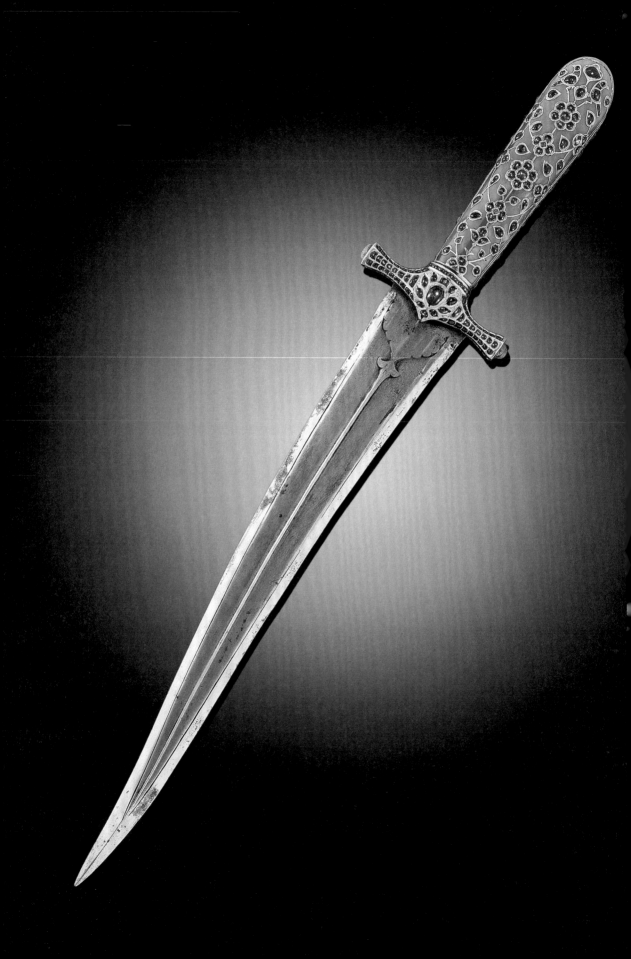

DAGGER (KARD)

North India, Mughal, 1620–50

Watered steel blade; jade hilt, inlaid with gold, rubies, and emeralds

L. 14 7/8 in. (37.7 cm), W. 2 3/4 in. (7 cm)

Mughal paintings include examples of this type of dagger, such as the one worn by Emperor Jahangir in a painting from the *Padshahnama* (1635–36, the illustrated chronicle of Shah Jahan's reign), which depicts him receiving Shah Jahan as a prince. Hilts of this form are known in gold, crystal, ivory, and jade.[3] The style seems to have fallen out of use by the end of Shah Jahan's reign.

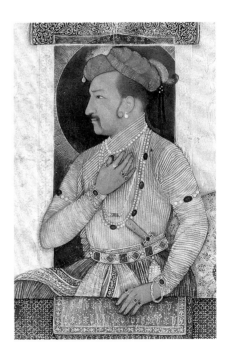

A dagger with a jade hilt is tucked into Emperor Jahangir's belt. Detail of *Jahangir Receives Prince Khurram, Ajmer, April 1616*, attr. to 'Abid, Mughal, 1635–36

CRUTCH HANDLE (*ZAFAR TAKIYA*)

North India, Mughal, ca. 1650
Jade, carved and inlaid with diamonds and agate
H. 1¼ in. (3.2 cm), W. 5 in. (12.8 cm)

Holy men (*faqirs*) in Indian paintings are often depicted with a small
crutch, known as a *zafar takiya* (cushion of victory), upon which they
lean while seated on the ground. These crutches are made of both
simple and precious materials, and the handles are usually curved.
This carved jade handle terminates at each end with a sensitively
rendered ibex or gazelle head.

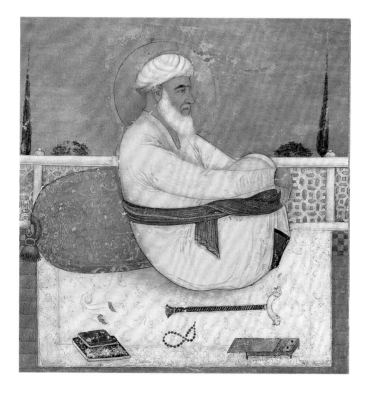

The *faqir* **Mulla Shah Badakshi meditates with a** *zafar takiya* **nearby.** Detail of
Mulla Shah Badakshi Sits in Meditation, Mughal, 1627–28

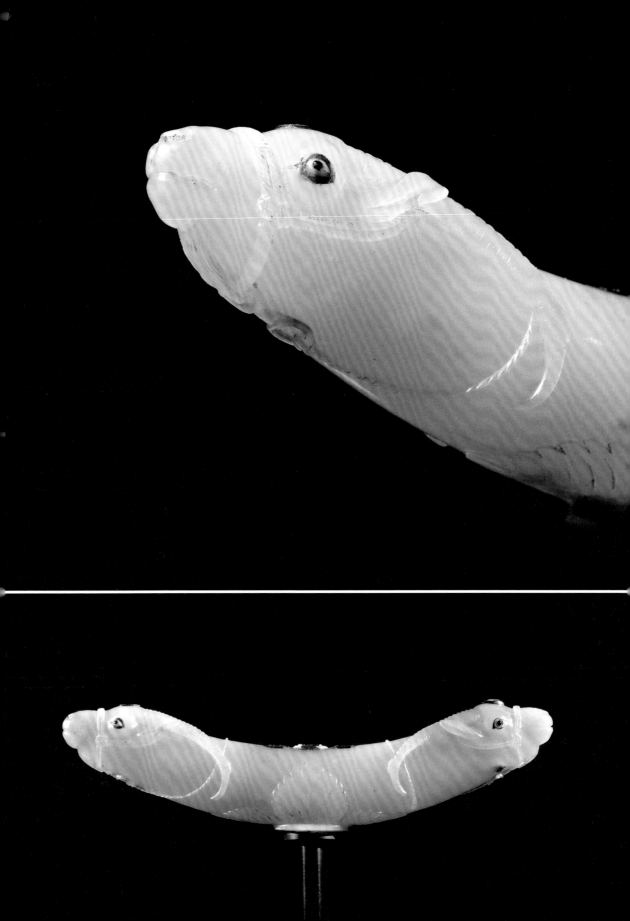

FLASK

North India, Mughal, 1650–1700

Rock crystal, inlaid with gold wire, rubies, and emeralds, with gold collar,
stopper, and foot

H. 3 ⅝ in. (9.2 cm), W. 2 ⅛ in. (5.5 cm)

The body of this small container was hollowed out from rock
crystal. Admired for its translucence and imbued with auspicious
associations, rock crystal was held in high esteem in both the
Islamic world and India from ancient times.[4]

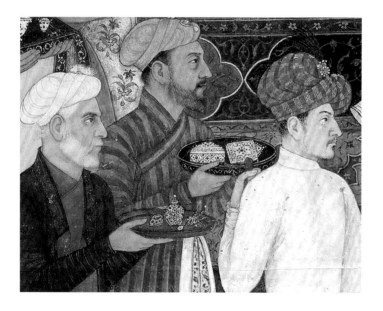

Attendants at a royal audience carry precious objects, including a flask with a stopper.
Detail of *Jahangir Receiving Prince Khurram, on His Return from the Deccan*, by Murar,
Mughal, ca. 1640

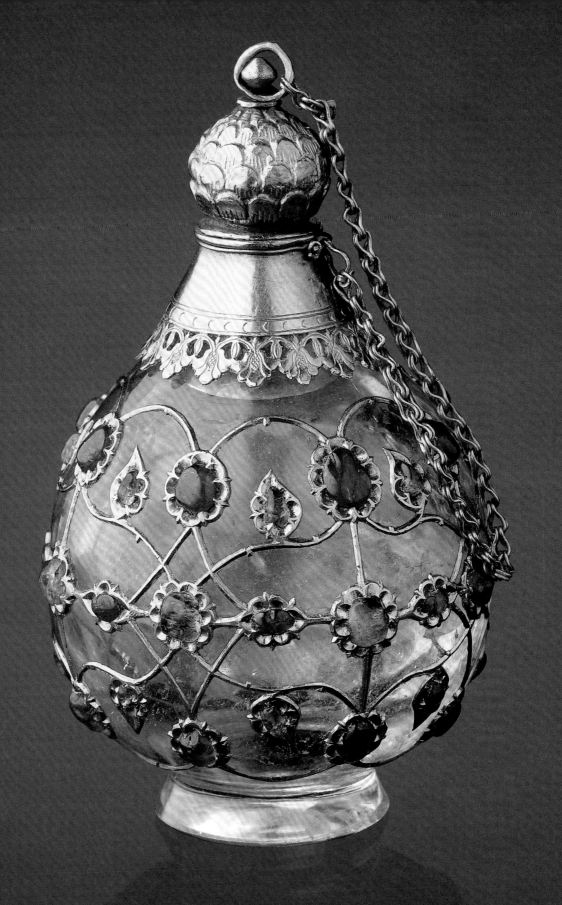

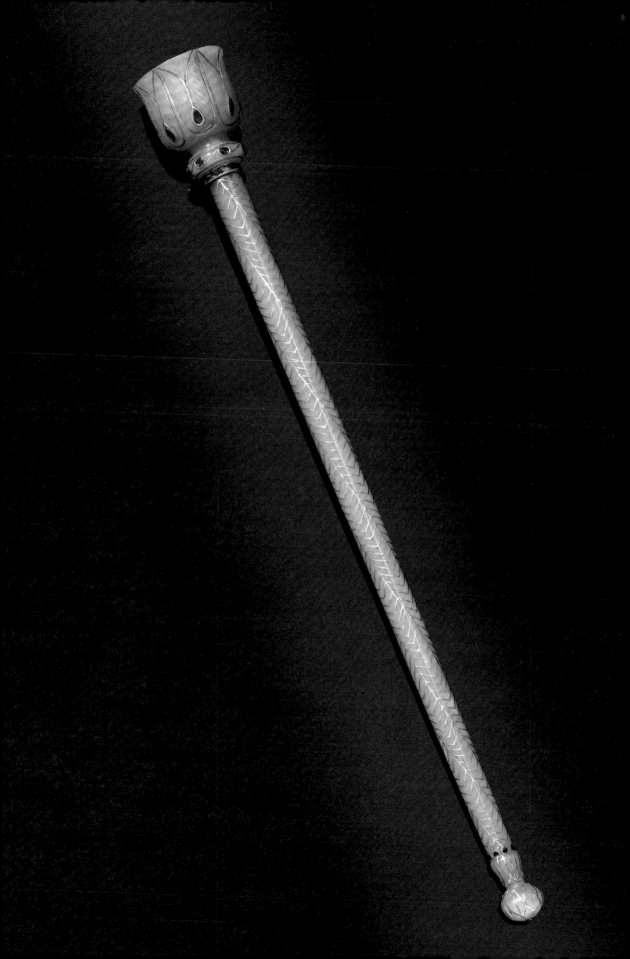

FLY WHISK HOLDER (*CHAURI*)

North India, Mughal, ca. 1700
Jade, inlaid with gold wire and rubies
L. 11³/₄ in. (29.8 cm), W. 1³/₈ in. (3.5 cm)

A fly whisk holder (chauri), fitted with a yak's-tail whisk or another kind of
plume, was used to keep flies away and to fan cool air at an esteemed dignitary. Functioning as a symbol of honor associated with sovereigns and divinities, this type of object is widely seen in ancient and medieval Indian art. The
attendant charged with waving the *chauri* was known as a *chamardar* and held
an official position at court.[5]

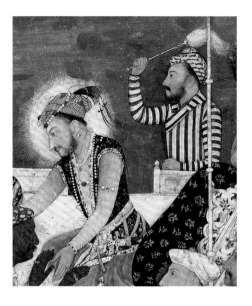

**A *chamardar* standing behind Prince Khurram fans the air
with a *chauri*.** Detail of *The Submission of Rana Amar Singh
of Mewar to Prince Khurram*, by La'lchand, Mughal, ca. 1640

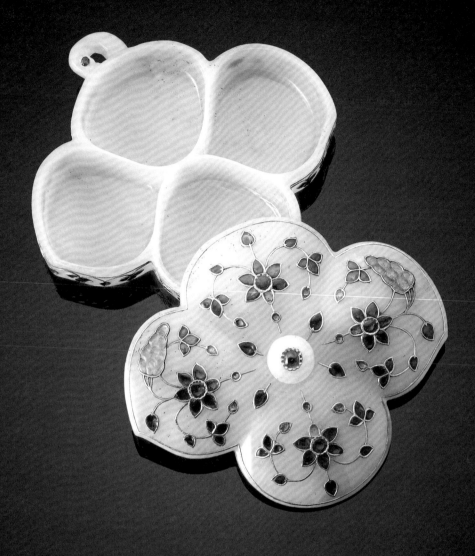

BOX (*DIBBI*)

North India, 1740–80

Jade, inlaid with gold wire, rubies, emeralds, and crystal

H. 1⁵/₈ in. (4.2 cm), W. 4¼ in. (10.8 cm), D. 4 in. (10.2 cm)

Compartmented containers were typically used for *paan*, a stimulating preparation made of betel leaf, areca nut, and tobacco that is chewed. In this lobed box the jade is inlaid with floral arabesques and carved bunches of grapes. Although a few other examples are known, the grape inlays carved from single plaques are unusual.[6]

PAIR OF FALCON ANKLETS

North India, ca. 1800

Jade, inlaid with gold and rubies

Each: Diam. 1⅝ in. (4.1 cm)

Falcons were considered a privilege of royalty.
The paraphernalia made to adorn and harness
these highly prized creatures, such as this pair of
anklets, is documented in contemporary texts
and images. The luxurious materials conveyed
the falcon's noble status.

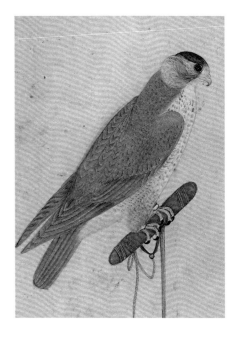

A falcon wears anklets that tether him to his post.
Detail of *Falcon*, by Mansur, Mughal, 17th century

BASE OF A WATER PIPE (*HUQQA*)

North India, 1740–80

Jade, inlaid with gold wire, diamonds, rubies, and emeralds

H. 6 3/8 in. (16.2 cm), Diam. 6 1/4 in. (16 cm)

Tobacco first appeared at the Mughal court in the late sixteenth century, having been introduced by Europeans by way of the Deccan courts. It soon became popular throughout India, where it was smoked primarily with a *huqqa*, or water pipe. By the eighteenth century the *huqqa* was routinely placed on a *masnad*, an upholstered seat that served as a throne or place of honor, and its appearance became essential at court. *Huqqa* bases were made from a number of materials; jade was relatively rare and conveyed higher status than metal or glass. The spherical shape of this example may be derived from the traditional Indian water vessel (*lota*). This particular object is likely the same *huqqa* base that the maharana of Udaipur loaned to the 1903 Delhi Durbar.[7]

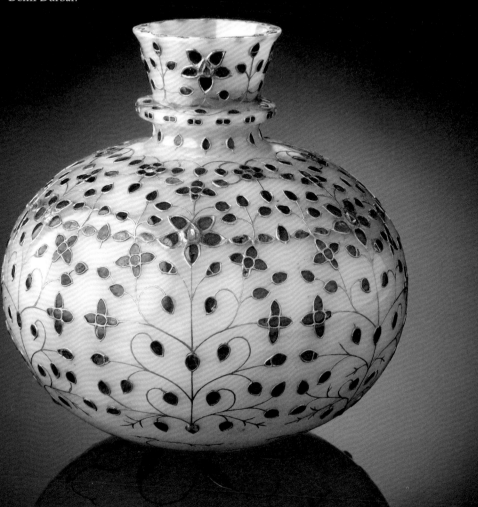

TWO *HUQQA* MOUTHPIECES (*MOHNAL*)

Left: North India, 1750–1800
Jade, inlaid with gold, rubies, and emeralds
H. 2⁷/₈ in. (7.1 cm), Diam. ³/₄ in. (1.9 cm)

Right: North India, ca. 1800
Jade, inlaid with gold, diamonds, rubies, and emeralds
H. 3¹/₄ in. (8.2 cm), Diam. ⁷/₈ in. (2.2 cm)

A water-pipe set was composed of a number of ele-
ments, including a bowl (*huqqa*), a burner (*chillam*),
its cover (*sarpush*), a pipe or snake (*nichah*) joining
the parts, and finally a mouthpiece (*mohnal*) fit onto
the end of the pipe. Smoke from the burner was
cooled as it passed through water in the *huqqa* base.
Smoking a *huqqa* was a common pastime among the
Indian nobility. Extravagant *huqqa* mouthpieces like
these examples were crafted of fine materials and
richly ornamented to create an object suitable for a
royal mouth.

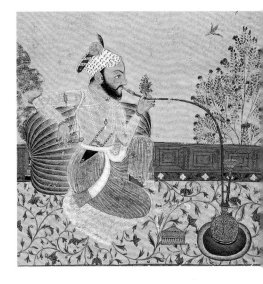

**A raja reclines on a pillow while smoking
from a *huqqa*.** Detail of *A Raja Smoking a
Huqqa*, Kota, ca. 1690–1710

39

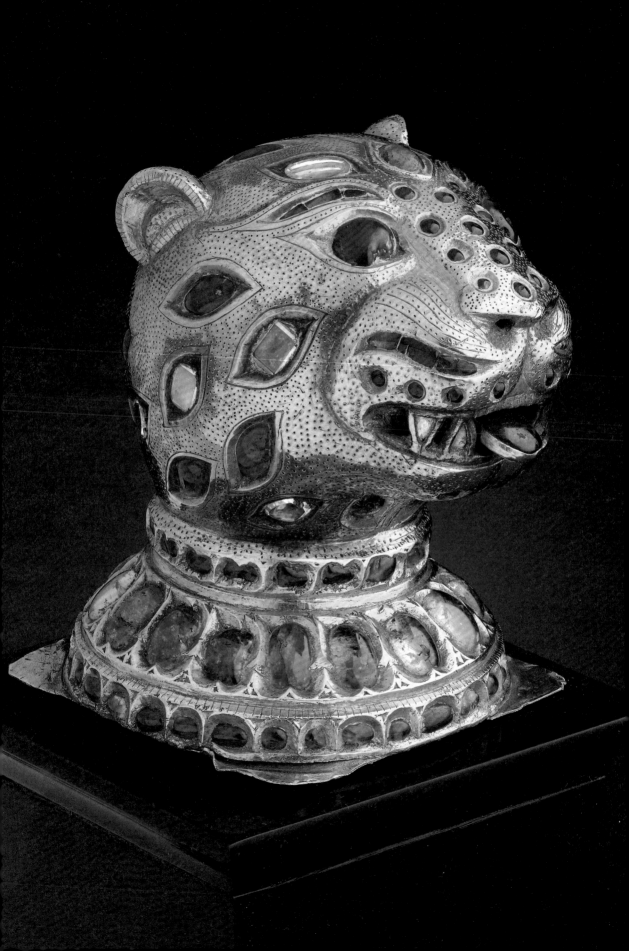

GOLD FROM *the* COURTS
of the NORTH *and* SOUTH

Gold was widely prevalent in the jeweled arts of India and retains its high status to the present day. It was used both to create the profiles of objects and to decorate them. Gold objects were fashioned with molds or by casting the metal around a lac, or resin, core and then decorating the form with inlaid gems. In the traditional Indian *kundan* gem-setting technique, stones are set into foiled beds of highly purified gold and held in place by pressing and shaping the soft metal around the edges, sometimes resulting in entire surfaces covered with rubies, emeralds, and diamonds, or other gems. Gold was also worked in a variety of other ways, such as filigree, chasing, engraving, and granulation, as well as spun into thread to make textiles.

Animal and bird forms, mythical figures, and floral shapes appear in gold objects such as finials, daggers, jewelry, and boxes. This selection from the Al-Thani collection displays gold gem-set objects from courts of north and south India, including a late eighteenth-century tiger's-head finial from the throne of the Mysore ruler Tipu Sultan.

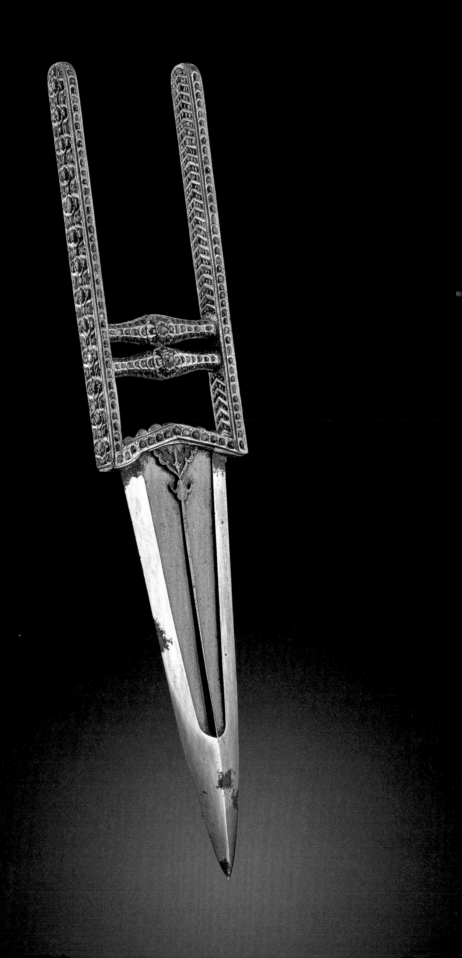

PUNCH DAGGER (*KATAR*)

North India, Mughal, ca. 1680–1720

Watered steel blade; gold hilt, inlaid with rubies, emeralds, and diamonds

L. approx. 7⅞ in. (20 cm)

The so-called Hindu punch dagger (*katar*) has a characteristic shape, composed of a triangular blade and a hilt with parallel grips flanked by rising guards. This form of dagger was widely adopted at the Indian courts, and jeweled examples such as this one were often given out in recognition of princely favor.

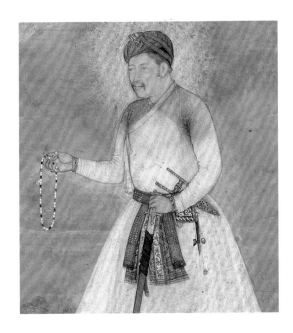

Emperor Akbar wears a *katar* tucked into his belt.

Detail of *Akbar with Lion and Calf*, by Govardhan, Mughal, ca. 1630

LOCKET PENDANT

North India, Mughal, probably 17th century

Gold, inlaid with rubies and emeralds

H. 2 3/4 in. (6.9 cm), W. 2 in. (5 cm), D. 1/2 in. (1.2 cm); weight: 113.7 g

This round, jeweled locket pendant might have once contained a miniature portrait (*shast*), an art form that was known at the Mughal court in the first half of the seventeenth century.[8] A numerical inscription on the back gives the Mughal-period equivalent of the object's weight, 113.7 grams.[9]

Emperor Shah Jahan holds a pendant portrait of himself.
Detail of *Shah Jahan on a Terrace*, by Chitarman, Mughal, 1627–28

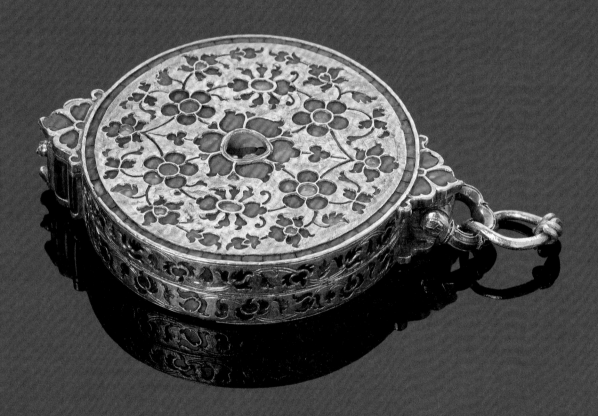

FINIAL FROM THE THRONE OF TIPU SULTAN

South India, Mysore, ca. 1790

Gold, inlaid with diamonds, rubies, and emeralds; lac core

H. 2 3/4 in. (6.8 cm), W. 2 1/8 in. (5.4 cm), D. 2 1/4 in. (5.5 cm)

This tiger's-head finial is one of eight that ornamented the grand throne of the ruler Tipu Sultan (r. 1782–99), known as the "Tiger of Mysore." Tipu adopted the symbol of a tiger as part of his royal identity, which is reflected in his courtly objects and weapons.[10] His octagonal throne, completed in 1793, featured a large-scale head of a crouching tiger at the base, a jeweled *huma* bird above the canopy, and eight tiger's-head finials on the surrounding railing (see pp. 15–16, figs. 2, 3).[11] Today, four of the eight finials are known, including this one; each has slightly different but similar gem settings and gold tooling.[12] The throne was dismantled after Tipu Sultan was killed in 1799, during the fall of Seringapatam. The finial presently stands on a later mount with a fragmentary inscription.

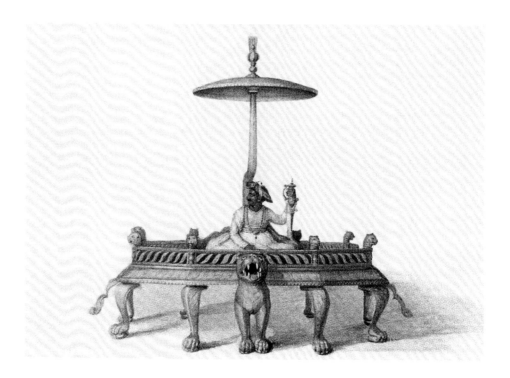

This watercolor of Tipu Sultan's throne indicates the original placement of the eight tiger's-head finials around the perimeter of the octagonal base.
Anna Tonelli, *Tipu Sahib, Sultan of Mysore (1749–1799), Enthroned*, 1800

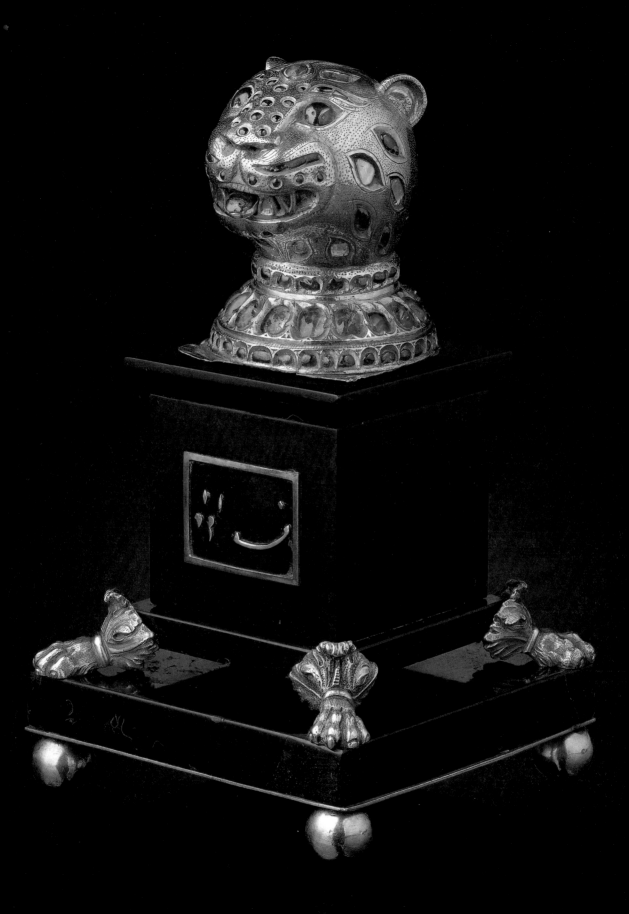

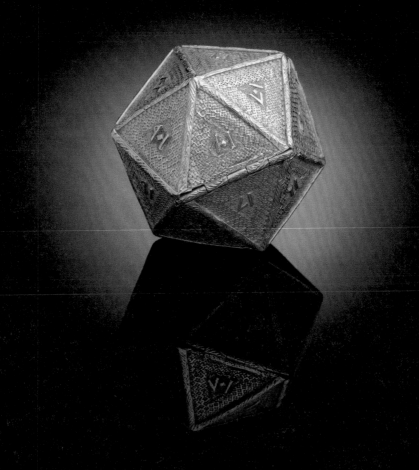

TIPU SULTAN'S MAGIC BOX

South India, Mysore, 1780–90

Gold

H. 2 1/4 in. (5.5 cm), W. 2 3/8 in. (5.8 cm), D. 1 7/8 in. (4.7 cm)

According to two manuscript notes found inside, this hammered gold box was part of the spoils taken from the treasury of Mysore following the defeat of Tipu Sultan by the British at the Battle of Seringapatam in 1799.[13] The box is in the form of an icosahedron, composed of twenty equilateral triangular faces, each bearing a number in Arabic. These numbers facilitate mathematical calculations that were first established by the ancient Greeks. Tipu Sultan was known to have been a scholar as well as a king, and his library contained many texts on mathematics and geometry.

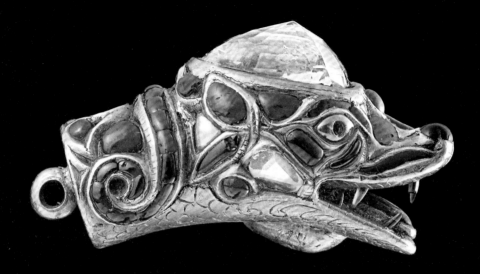

ORNAMENT IN THE SHAPE OF A *MAKARA* HEAD

South India, Mysore or Tanjore, 1775–1825

Gold, inlaid with diamonds, rubies, and yellow sapphire

H. 7/8 in. (2.1 cm), W. 3/4 in. (1.7 cm), D. 1 5/8 in. (4.1 cm)

The *makara*, a kind of mythical fish or dragon, is a prolific form
found throughout south Indian art and architecture. On a small
scale, *makara* heads often ornament the terminals of wrist bangles
or pieces of furniture.

PEN CASE AND INKWELL (*DAVAT-I DAULAT*)

Deccan or north India, 16th or 17th century, or later

Gold, inlaid with diamonds, rubies, and emeralds

Pen case: H. 1 5/8 in. (4 cm), W. 12 1/8 in. (30.6 cm); inkwell: H. 4 1/2 in. (11.4 cm),

Diam. 2 1/8 in. (5.4 cm)

The double-barrel form of this pen case and attached inkwell (*davat-i daulat*) is known through surviving examples in jade from India and in metalwork from Iran, and through representations in paintings dating from the late sixteenth and seventeenth centuries.[14] Here, the domed profile of the inkwell and the heavy gold body of the piece as a whole suggest a south Indian style. However, an object of this particular style is hitherto unknown.

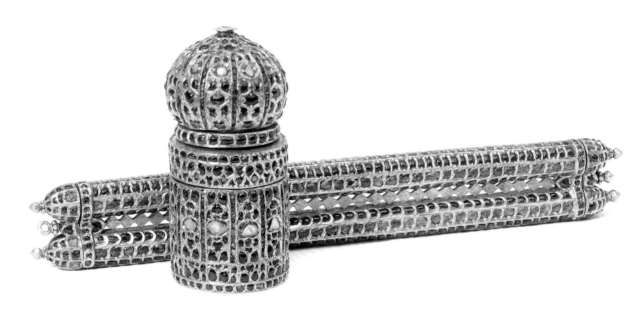

ROSEWATER SPRINKLER (*GULABPASH*)

North India, 17th century (base), late 18th century (neck)
Metal, inlaid with rubies, emeralds, and pearls
H. 10 ⅛ in. (25.5 cm)

This bottle with a globular body is identifiable as a *gulabpash*, or rosewater sprinkler, on account of the small aperture at the top, which would have been used to distribute small amounts of sweet-smelling water infused with rose petals. This particular *gulabpash* is composed of two sections from different dates, which have been joined at the base of the neck. The body is of an older style and may date from as early as the seventeenth century, while the neck is a replacement, probably dating from the late eighteenth century.

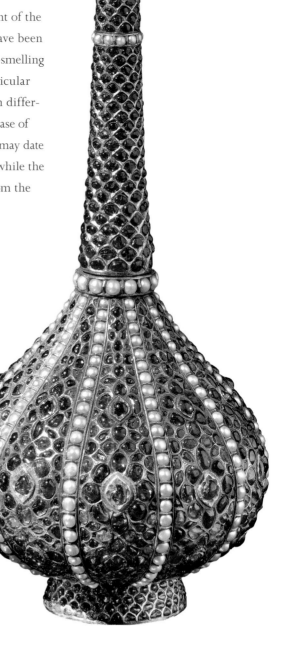

BIRD-SHAPED ORNAMENT OR FINIAL

South India, 1775–1825

Gold, inlaid with diamonds, rubies, and emerald, with hanging seed pearls; lac core

H. 1 1/8 in. (2.8 cm), W. 1 1/8 in. (2.8 cm), D. 1/2 in. (1.3 cm)

Bird-shaped ornaments, including this example and another belonging
to Tipu Sultan, may have surmounted small staffs or finger rings.[15] A
threaded bolt at the bottom makes the ornament detachable. The form
resembles a hawk, particularly in the crest at the back of the head, sug-
gesting the wearer's interest in hunting.

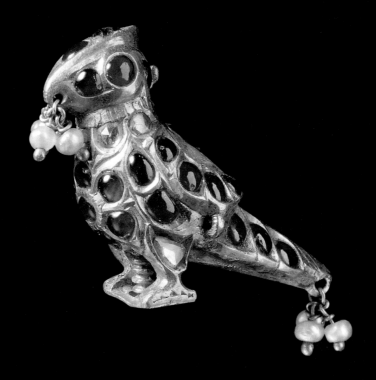

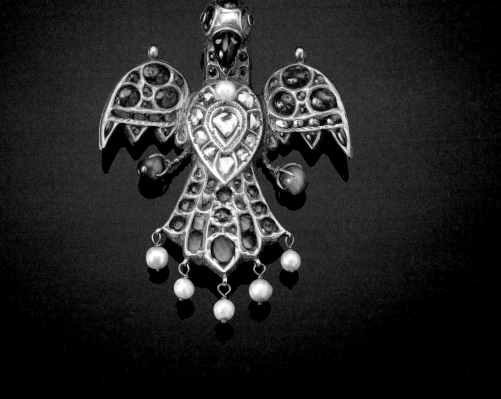

BIRD-SHAPED PENDANT

North India or south India, probably 18th century

Gold, inlaid with diamonds, rubies, and emeralds,

with hanging seed pearls; lac core

H. 2⅝ in. (6.6 cm), W. 3¼ in. (8.2 cm)

Bird-shaped pendants, suspended from
hooks atop the wings, are documented in
portraits of eighteenth-century rulers.[16]

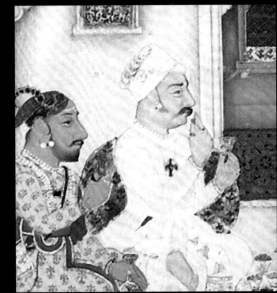

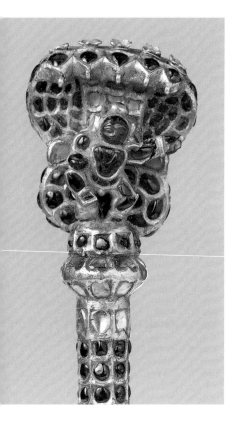

RITUAL SPOON (*UDDHARANE*)

South India, ca. 1800

Gold, inlaid with diamonds and rubies

H. 6 5/8 in. (16.7 cm), W. 1 5/8 in. (3.9 cm)

This jeweled spoon is ornamented with a dancing figure of Krishna under the multiheaded snake Kaliya, whom Krishna suppresses with his divine dance. Such spoons, known as *uddharane*, were most likely used in Hindu temples to facilitate rituals involving water, including *arghya* (to wash the hands), *padya* (to offer water to a deity), and *achamaniya* (to sip water and rinse the mouth).[17] Lavish ritual objects were often commissioned by local rulers and donated to temples.[18]

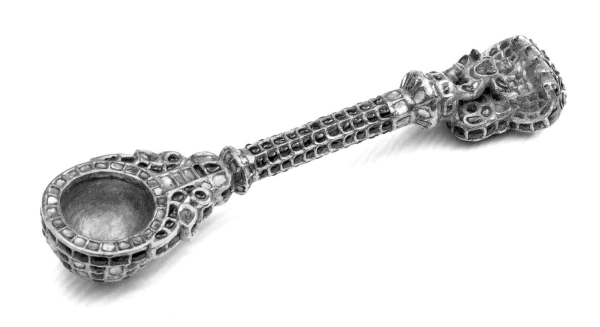

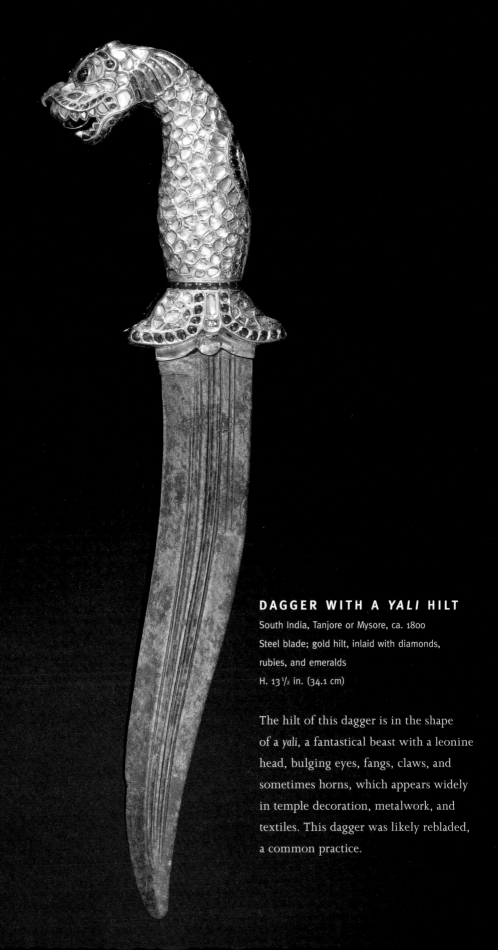

DAGGER WITH A *YALI* HILT

South India, Tanjore or Mysore, ca. 1800
Steel blade; gold hilt, inlaid with diamonds,
rubies, and emeralds
H. 13 ½ in. (34.1 cm)

The hilt of this dagger is in the shape
of a *yali*, a fantastical beast with a leonine
head, bulging eyes, fangs, claws, and
sometimes horns, which appears widely
in temple decoration, metalwork, and
textiles. This dagger was likely rebladed,
a common practice.

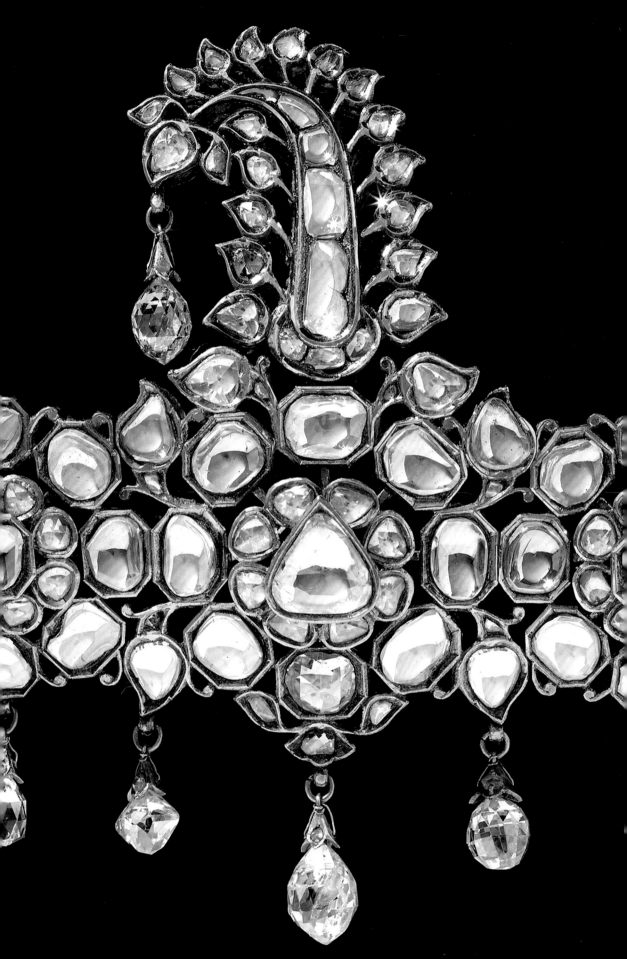

TRADITIONAL *and* MODERN STYLES

The selected works in this section represent styles of jewelry that were worn by men and women at the Indian courts. Necklaces, rings, forehead ornaments, belts, earrings, buttons, anklets, and toe rings were common forms, used both in daily life and for special occasions or ceremonies. Of particular focus was the royal male head, which was adorned with a jeweled ornament (*sarpesh*) that was attached with plumelike aigrette (*jigha*) and worn over the turban with strings of pearls. A Nepalese crown integrating all these features demonstrates the complete look.

The majority of jeweled objects produced from the seventeenth century onward remained within a conservative tradition of shapes that was mainly based on Mughal-period court styles and exhibited a taste for uncut and foiled gems. However, by the nineteenth century the Indian jeweled arts began to incorporate Western styles and techniques. Most notably, the maharajas and other royalty acquired a taste for highly faceted gems, and traditional jewelry forms were reinterpreted with a more modern sensibility. This development can be seen in a braid ornament (*jadanagam*), which combines a traditional profile with Western elements such as faceted diamonds and open-set naturalistic leaf forms.

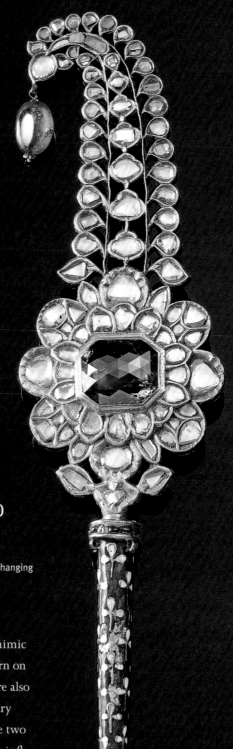

TURBAN ORNAMENT (*JIGHA*)

Front and back

North India, Mughal, 1675–1750

Gold, set with spinel, diamonds, and rubies, with hanging
emerald; enamel on stem and reverse

H. 8⁷/₈ in. (22.5 cm), W. 2¹/₈ in. (5.4 cm)

Jighas, or turban ornaments, generally mimic
the shape of feather plumes that were worn on
the turban in the Mughal period. They are also
akin to sixteenth- and seventeenth-century
European jeweled hat aigrettes, and these two
formal developments may have mutually influ-
enced each other.[19] This piece is ornamented even
on the stem, which, although it would have been
hidden in the folds of the turban, is covered in a
striking red and white enameled design.

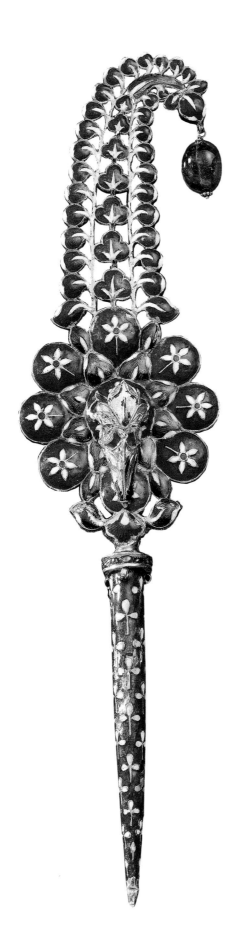

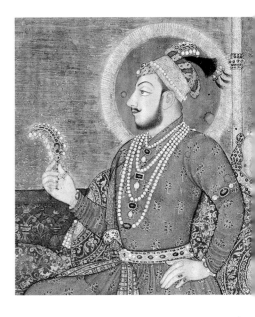

Muhammad Shah presents a *jigha* to Maharaja Raj Singh of Kishangarh. Detail of *Muhammad Shah with Six Courtiers*, Kishangarh, ca. 1725

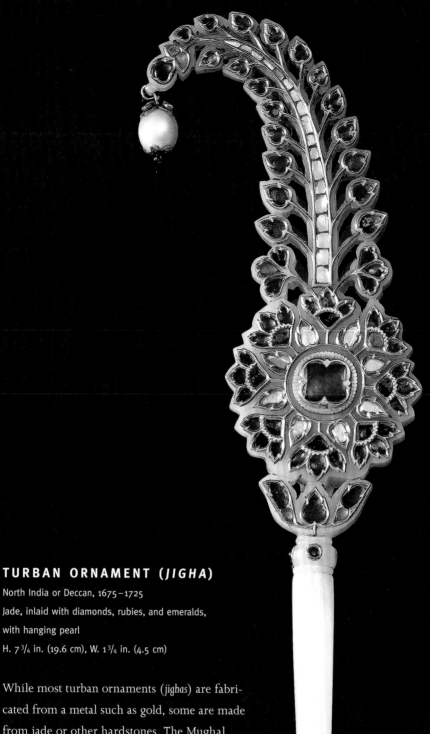

TURBAN ORNAMENT (*JIGHA*)

North India or Deccan, 1675–1725
Jade, inlaid with diamonds, rubies, and emeralds,
with hanging pearl
H. 7¾ in. (19.6 cm), W. 1¾ in. (4.5 cm)

While most turban ornaments (*jighas*) are fabricated from a metal such as gold, some are made from jade or other hardstones. The Mughal emperor Aurangzeb (r. 1658–1707) is recorded as giving a jasper turban ornament in 1673 to the general Shuja'at Khan as a reward for suppressing an uprising in Afghanistan.[20]

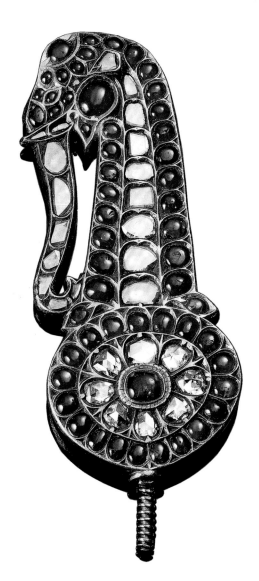

ELEPHANT-SHAPED TURBAN ORNAMENT (*JIGHA*)

Front and back

South India, 1775–1825

Gold, set with rubies, diamonds, and emeralds

H. 3¼ in. (8.2 cm), W. 1⅛ in. (2.9 cm)

This turban ornament (*jigha*) is composed in the playful shape of an elephant, which is also delineated on the reverse through finely engraved lines. The screw at the bottom indicates that this *jigha* was attached to another piece of jewelry, making it a convertible modern form.[21]

Azim ud-Dala, Nawab of Arcot, wears a *jigha* of a similar form.
Detail of Thomas Hickey, *Azim ud-Dala, Nawab of Arcot, and His Son Azam Jah*, 1803

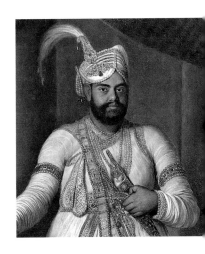

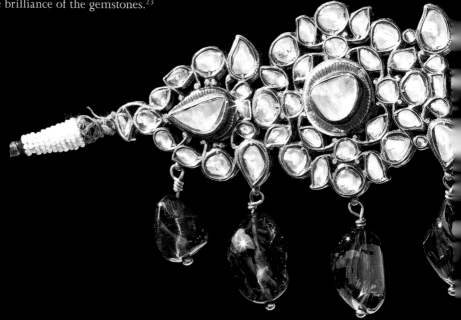

TURBAN ORNAMENT (*SARPESH*)

South India, Hyderabad, 1800–50
Gold, set with diamonds, with hanging spinels of earlier date; enamel on reverse
H. 7 3/8 in. (18.5 cm), W. 10 3/4 in. (27.2 cm)

The *sarpesh*, from *sar*, meaning head, and *pesh*, meaning fastener, was a
jewel used to ornament the front of a turban.[22] While this *sarpesh* dates
from the nineteenth century, earlier spinels, possibly added recently,
adorn the piece. The diamonds in this *sarpesh* have been set in the tradi-
tional *kundan* technique, in which each gemstone is laid into a bed of
gold. Lining the beds with silver foils was also a method used to
enhance the brilliance of the gemstones.[23]

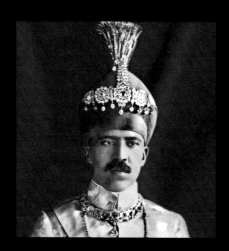

**In his wedding portrait, the nizam of Hyderabad wears
a similar *sarpesh*.** Detail of Lala Deen Dayal, *Wedding
Portrait of Asaf Jah VII, Osman Ali Khan, Nizam of
Hyderabad*, 1906

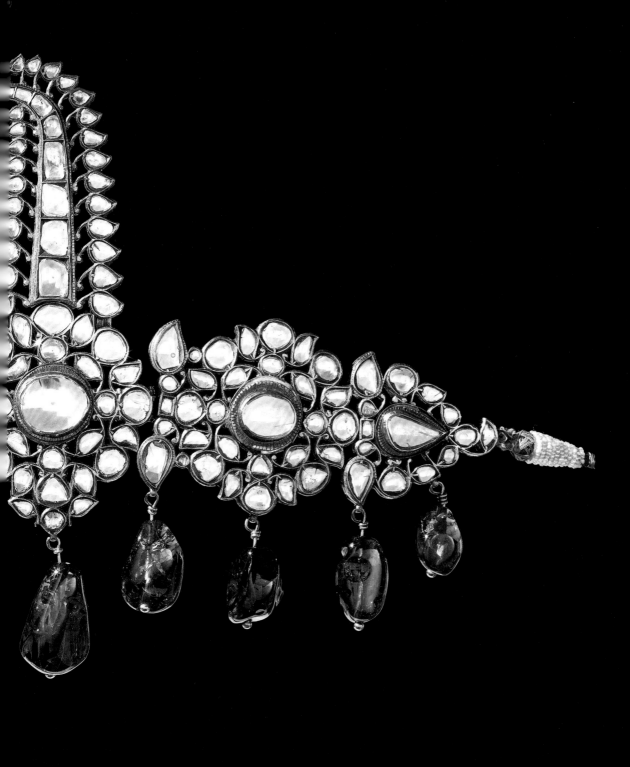

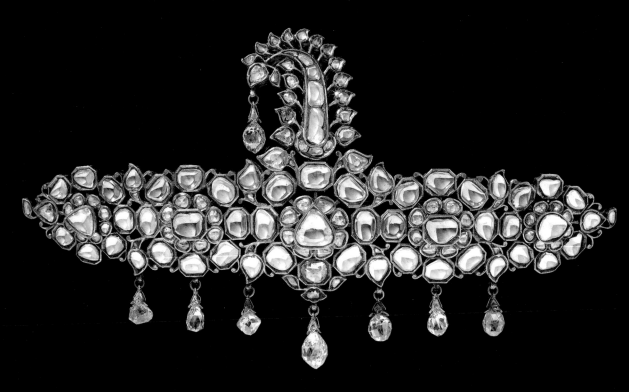

TURBAN ORNAMENT (*SARPESH*)

Front and back

North India, Jaipur, 1825–75

Gold, set with diamonds; enamel on reverse

H. 4⅛ in. (10.5 cm), W. 7⅝ in. (19.2 cm)

This opulent *sarpesh* is ornamented with five openwork panels in the form of foliate clusters set with foiled diamonds, from which seven diamond drop beads are suspended. The distinct red, green, dark blue, and powder blue enameling on the reverse of the *sarpesh* suggests that this object was produced in Jaipur. Though this piece has many superficial similarities to the diamond sarpesh from Hyderabad in the Al-Thani collection (pp. 62–63), on closer examination, differences in the design and palette of the enameling and in details of the gem settings reveal that these pieces were created in two distinct traditions.[24] This diamond *sarpesh* is very unusual in its faceted diamond drop beads; most diamond *sarpeshes* have emeralds as drop ornaments.[25]

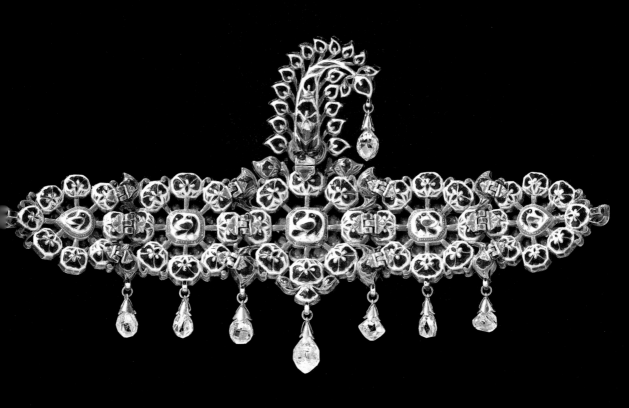

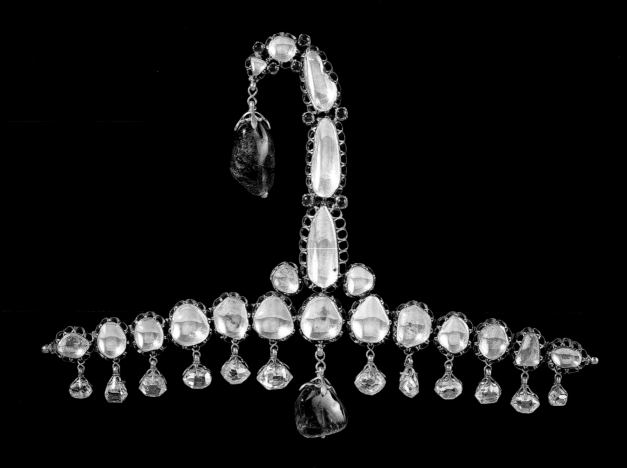

TURBAN ORNAMENT (*SARPESH*)

North India, 1875–1900

Gold, set with diamonds, rubies, and spinels

H. 5 3/8 in. (13.7 cm), W. 7 7/8 in. (19.8 cm); spinels: 37.5 ct (top), 54 ct (bottom)

This *sarpesh* is constructed with a hybrid technique. The suspended diamonds are set in Western claw, or coronet, mounts, rather than in traditional Indian *kundan* settings, which cradle the gems in metal. However, the fixed diamonds, backed in silver foil, are set using that classic technique.

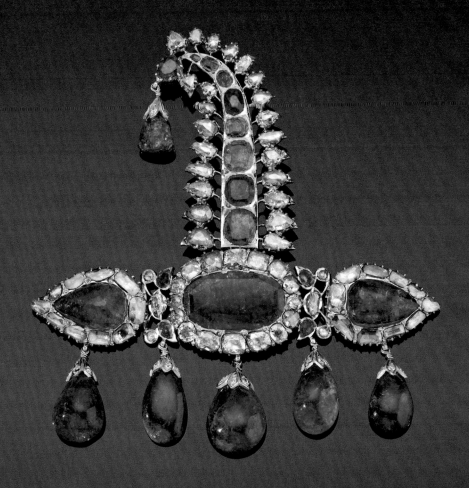

TURBAN ORNAMENT (*SARPESH*)

South India, probably Hyderabad, ca. 1900

Gold, set with emeralds and diamonds

H. 4⁷/₈ in. (12.4 cm), W. 4⁷/₈ in. (12.4 cm)

Emeralds—gems favored by Mughal emperors and Hyderabadi nizams alike—were originally sourced mainly from Portuguese and Spanish gem dealers who acquired them from the Inca, Maya, Toltec, and Aztec peoples, whose dynastic emerald collections became booty in the early sixteenth century.[26] By midcentury, the conquistadors were actively mining and exporting emeralds from Colombia to markets in the East, especially India. The gems in this *sarpesh* are set similarly to those in necklaces found in the collection of the nizams of Hyderabad.[27]

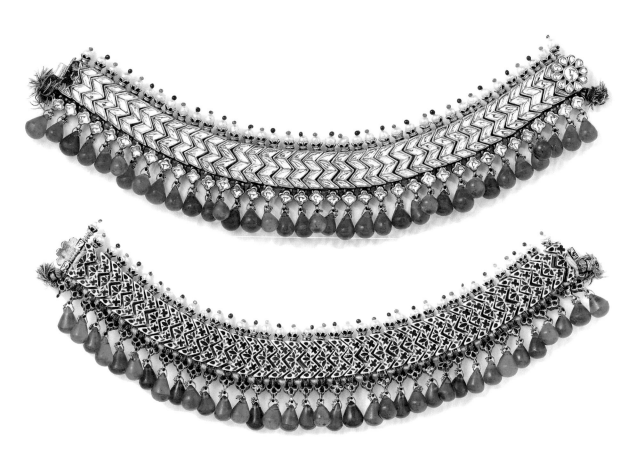

PAIR OF ANKLETS

North India, Jaipur or Bikaner, 1800–50

Gold, set with white sapphires, with attached pearls and hanging glass beads; enamel on reverse

Each: H. 2 in. (5 cm), L. 10 1/4–10 5/16 in. (26–26.2 cm)

Worn by both women and men, anklets take many forms in India. They may be made of solid sheet or cast metal, or they may be composed of flexible elements, as seen in this pair, which features a series of jeweled chevron-shaped units joined by silk thread.

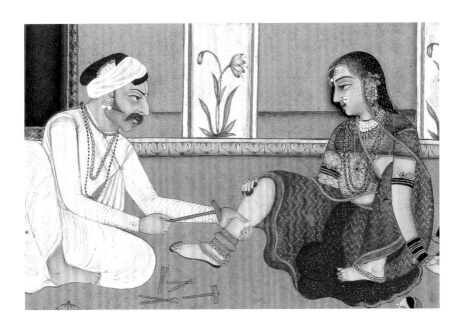

A goldsmith fits an anklet to a client's leg using a small hammer.

Detail of *In a Goldsmith's Workshop*, Bundi, ca. 1760

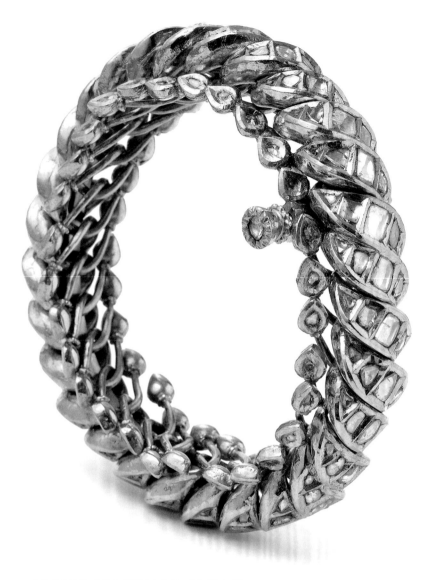

ANKLET (*DASTBAND ALMAS*)

South or north India, Hyderabad or Rajasthan, 1800–50

Gold, set with diamonds

Diam. 4 in. (10 cm)

In the Rajput courts anklets of this type (*dastband almas*) were awarded by the ruler as princely recognition and were worn on the right ankle of the recipient in a custom known as *ta'zim*, or honor. The investiture of the anklet entitled the recipient to a position at durbars and to certain legal privileges and exemptions.[28] This form is used in more than one place in India; a number of pairs of similar gold-and-diamond anklets or bracelets were in the treasury of the nizams of Hyderabad.[29]

PAIR OF BANGLES (*KADA*)

North India, Jaipur, ca. 1775–1825
Gold, set with rubies, diamonds, and pearls; enamel on interior; lac core
Each: Diam. 2⁷/₈ in. (7.2 cm)

Bangles are a ubiquitous form of jewelry in India. While today they are worn by all
women, historically certain types of bangles were reserved for those who were
married, a custom that continues in some tribal areas. Each bangle in this pair has
a core made of lac, a hard resin produced from the secretions of an insect native
to Indian forests. A traditional material used in bracelets and other objects since the
Indus Valley period (ca. 2500–1750 B.C.), the lac creates a solid base for the outer
layers and ornaments, often made in soft metals such as gold.[30]

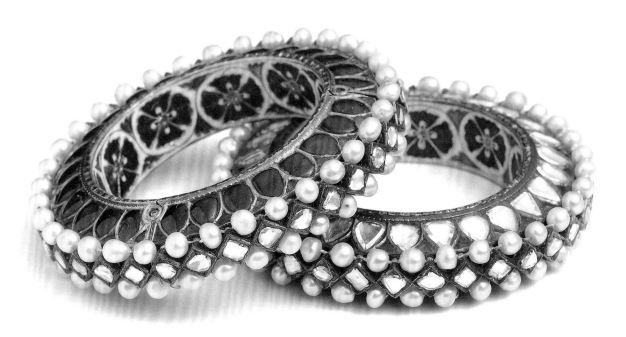

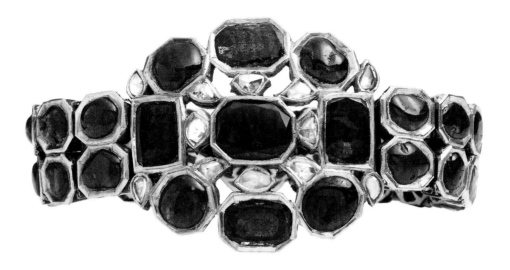

BRACELET

North India, Jaipur, ca. 1800

Gold, set with rubies and diamonds; enamel on reverse

H. 1 $^7/_8$ in. (4.7 cm), L. 8 $^7/_8$ in. (22.4 cm)

This bracelet, made to be worn by a man, is typical of examples depicted in Indian paintings. Its reverse is enameled in translucent red and green on an opaque white background, a palette usually associated with Jaipur production.

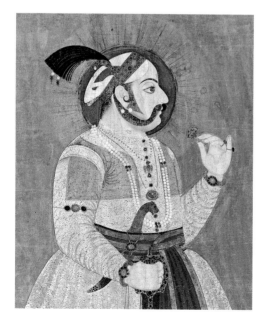

On each wrist, Maharana Amar Singh II of Mewar wears a bracelet. Detail of *Maharana Amar Singh*, Udaipur, ca. 1735–40

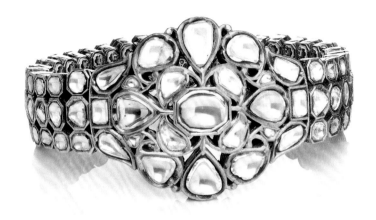

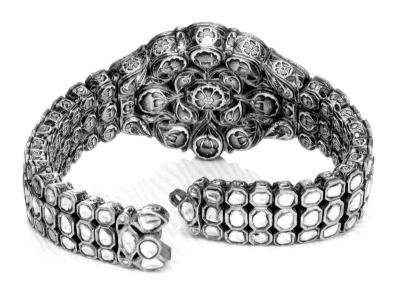

PAIR OF BRACELETS

India, Varanasi, 1800–25

Gold, set with diamonds; enamel on reverse

Each: H. 1 3/4 in. (4.3–4.4 cm), L. 9 1/2 in. (24 cm)

These bracelets, intended to be worn by a man, are decorated on the reverse in the distinctive pink enamel (*gulabi minakari*) often associated with Varanasi (Benares).[31] The design and ornamentation of these bracelets were in fashion in the late eighteenth and early nineteenth centuries.

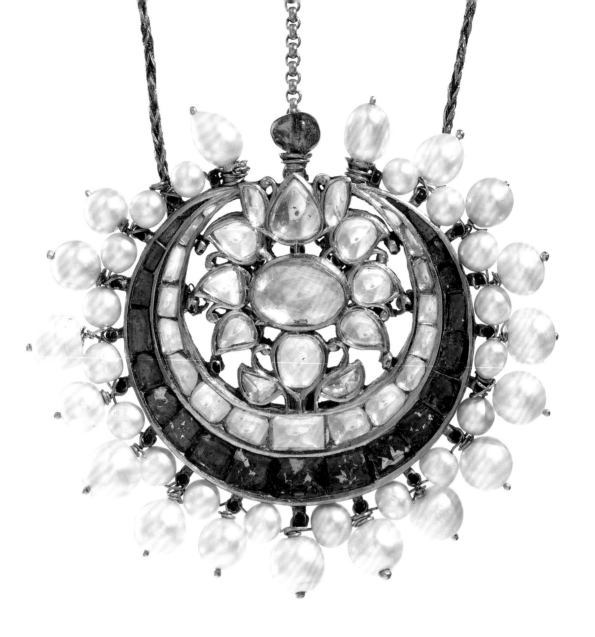

FOREHEAD OR TURBAN ORNAMENT (*TIKA*)

Front and back

North India, Punjab, ca. 1900

Gold, set with emeralds and diamonds, with attached pearls; enamel on reverse

H. 2 7/8 in. (7.3 cm), W. 3 1/4 in. (8.2 cm)

A *tika* is a woman's forehead ornament, worn suspended from a chain or from a
single strand of pearls. Though this piece was most likely worn in that manner, its
large scale suggests that it may have also served as a turban ornament. The reverse,
enameled in translucent red, green, and blue with opaque white, depicts a peacock
at the center of the crescent, flanked by other birds amid foliage.

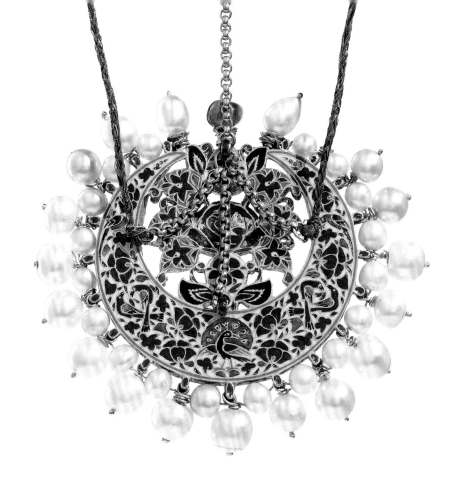

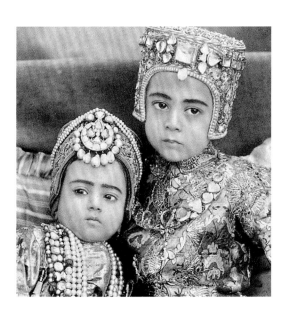

Sahebzadi Ahmed Unnisa (left) wears a *tika* on her forehead. Detail of
*Sahebzadi Ahmed Unnisa and Sahebzada Salabath Jah, daughter and
son of Asaf Jah VI, Mahbub Ali Khan, Nizam of Hyderabad,* ca. 1910

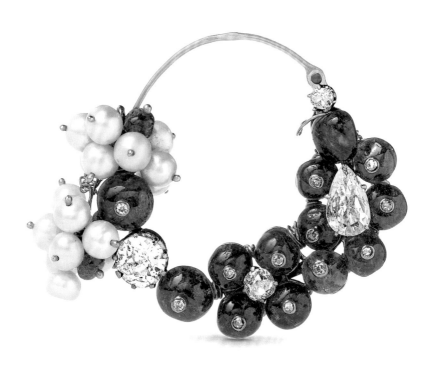

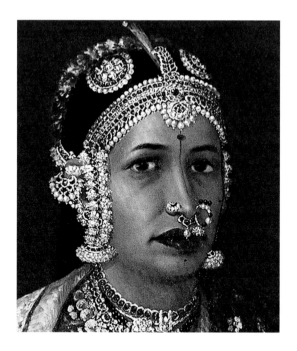

TWO NOSE RINGS (*NATH*)

Western India, 1925–50

Gold, with diamonds, seed pearls, and rubies or emeralds

Top (rubies): H. 1⁵/₈ in. (4.2 cm), W. 1¹/₂ in. (3.7 cm)

Bottom (emeralds): H. 1¹/₂ in. (3.6 cm), W. 1³/₈ in. (3.4 cm)

The *nath*, a decorated nose ring, is one of three types of nose ornament worn in India, the others being the septum ornament and the stud.[32] It ranges in form from a simple wire to an elaborate assembly of gems that needs to be connected to a head-dress to support its weight. A *nath* is typically worn by married women in the left nostril. Nose rings were widely assimilated throughout India; the type of nose ring seen here was documented along with other Hindu jewelry in the *A'in-i Akbari*, written in the sixteenth century.[33]

The *nath* in the sitter's left nostril indicates that she is a married woman. Detail of Ravi Varma, *H. H. Janaki Subbamma Bai Sahib, Rani of Pudukkottai*, 1879

PAIR OF EARRINGS (*PANKHIYAN*)

Central India, ca. 1900

Gold, set with diamonds, with pearls and glass beads

Each: H. 3–3 1/8 in. (7.6–7.9 cm), W. 1 3/8–1 1/2 in. (3.5–3.7 cm)

These early twentieth-century earrings were designed with a hybrid technique.
Clusters of small pearls are a typical feature of women's jewelry in India, whereas the
diamonds are mounted in Western-style claw settings instead of traditional *kundan*
settings. The diamonds are likely older, having been recut to their present form.

SEAL RING WITH HIDDEN KEY

South India, Hyderabad, 1884–85

Gold, set with spinel

H. 1 1/8 in. (2.7 cm), W. 1 1/8 in. (2.8 cm), W. (with key extended) 2 1/8 in. (5.3 cm)

The inscription, carved in reverse on the spinel, indicates that this ring once belonged to Mahbub 'Ali Khan Asaf Jah VI (r. 1869–1911), nizam of Hyderabad, who ascended to the throne at the age of two and was invested with full administrative powers when he turned eighteen in 1884. It is dated A.H. 1302 (October 21, 1884–September 11, 1885) and when stamped reads, "The Rustam of the Age, the Aristotle of the Time, Fath Jang Sipah Salar 1302 [1884–85] Muzaffar al-Mamalik Nizam al-Mulk Mir Mahbub 'Alikhan Bahadur Asaf Jah Nizam al-Dawlah." Thus, the ring may have been created to celebrate the nizam's transition to head of state. The top is hinged and flips open to reveal a hidden, extendable key made of gold.

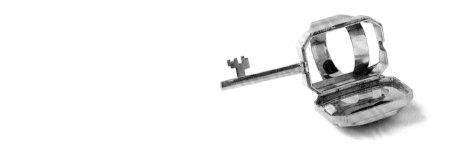

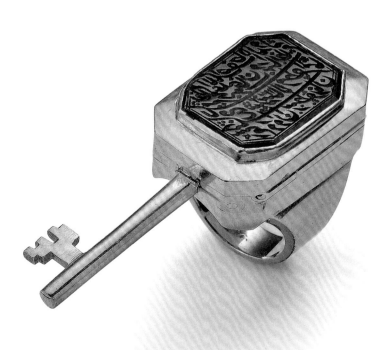

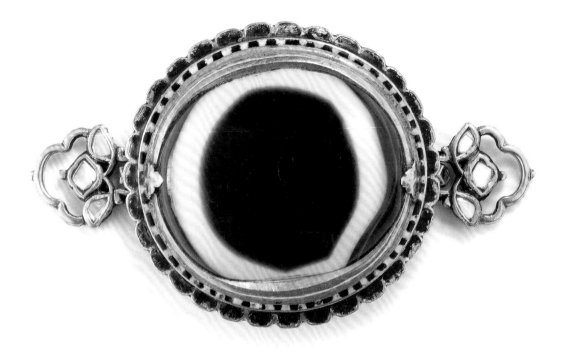

UPPER-ARM ORNAMENT (*BAZUBAND*)

North India, Lahore or Jaipur, 1800–50
Gold, set with agate, diamonds, and enamel; enamel on reverse
H. 1⅝ in. (3.9 cm), W. 2¾ in. (6.9 cm)

Agate has been so extensively available in Gujarat that a region in the Rajpipla Hill range is called *pathar kshetra*, or "land of agates." This jewel served as the main part of a *bazuband*, or a band worn around the bicep.[34] The agate is exceptional, being an unusually large stone of the rare banded variety. The visual similarity of banded agate to an eye was sometimes considered a protection against curses.[35]

Shah Jahan wears a *bazuband* on his left bicep.
Shah Jahan on Horseback, by Payag, Mughal, ca. 1630

JEWELED BUCKLE AND SLIDE ON SILK SASH

North India, possibly Delhi, ca. 1900

Buckle and slide: gold set with emeralds, rubies, and diamonds; sash: silk embroidered with gold thread

Buckle: H. 2 ⅝ in. (6.5 cm), W. 3 ¼ in. (8 cm); slide: L. 4 ¾ in. (12.1 cm); sash: W. 2 in. (5.1 cm)

A sash of this type was worn by an Indian prince or courtier diagonally across the chest, often in tandem with a sword. Beginning in the late eighteenth century many elements of Indian court attire reflected Western influence, and the inspiration for this design was likely European military dress. The shapes of the buckle and slide in this example are European, whereas the kundan-style setting of the gems is an Indian convention.

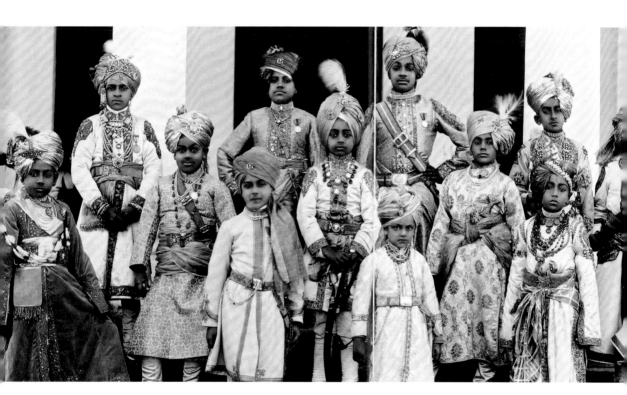

Page boys to the king and queen of England during their 1911 visit were selected from the children of rulers loyal to the British Crown. Detail of Promod Kumar Chatterjee, *Page Boys to King George V and Queen Mary*, 1911

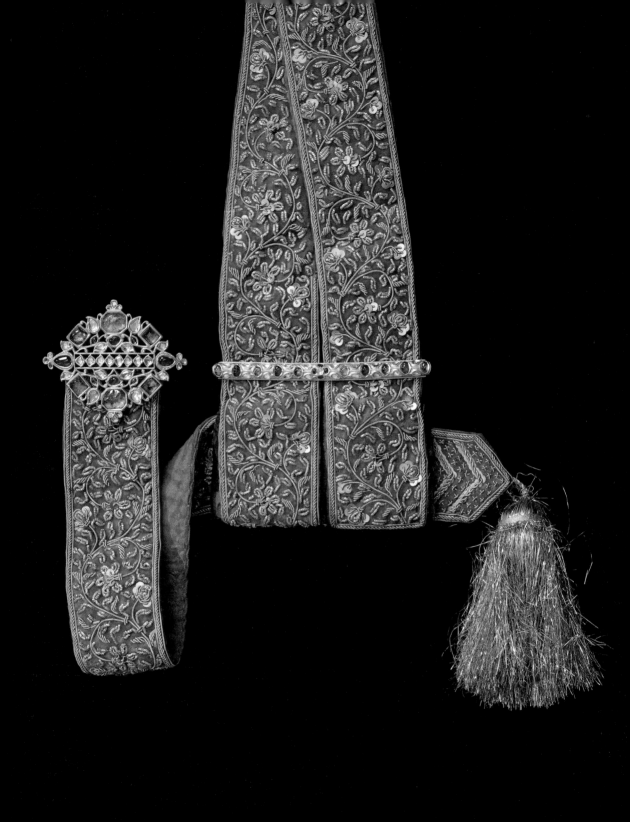

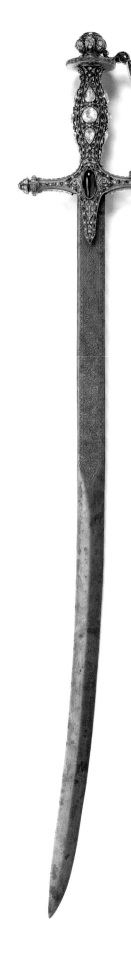

CEREMONIAL SWORD

South India, Hyderabad, 1880–1900
Steel blade; gold hilt, inlaid with diamonds, rubies, and emeralds, with applied silver wire
Overall: L. 38 5/8 in. (98 cm); hilt: L. 9 1/4 in. (23.5 cm)

In design and manufacture this sword is typical of the later workmanship of south India, most probably Hyderabad. Although silver, seen here in the applied ornamentation, was employed less often than gold for royal jewelry, it was used quite extensively in Lucknow and the Deccan, including at the Asaf Jah VI court in Hyderabad. This sword is very similar to one that belonged to the Asaf Jah treasury, which was documented when the Nizam's Jewelry Trust was founded in 1951 by the last nizam, Osman 'Ali Khan (r. 1911–48), and for that reason it has been called the "Nizam of Hyderabad's Sword" in recent times.[36]

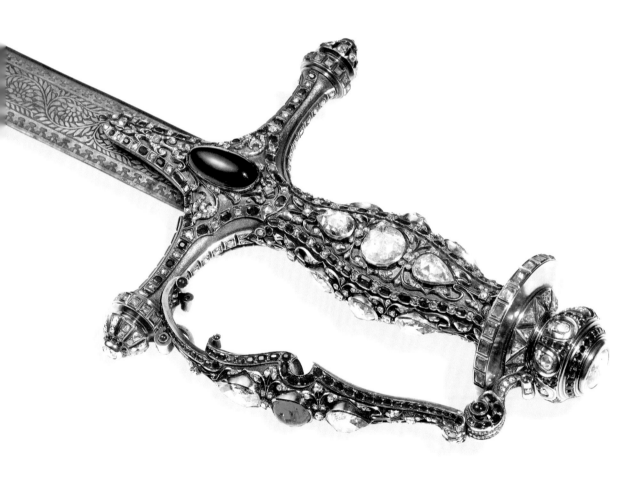

NECKLACE (*KANTHI*)

South India, Hyderabad, 1850–75

Gold, set with diamonds and emerald; enamel

H. 10 1/4 in. (26 cm), W. 7 3/4 in. (19.6 cm)

Large collar-shaped necklaces (*kanthi*) are seen in late nineteenth-century portraits of Indian princes. This example contains eight brilliant-cut diamonds of about ten to fifteen carats each. A buckle in the treasury of the nizams of Hyderabad is comparable in its style of diamond setting and engraving work on the reverse.[37] The style of this necklace was known in both north and south India.

Maharaja Ripudaman Singh of Nabha, probably photographed during the Delhi Durbar, wears a diamond necklace. Detail of *His Highness the Crown Prince Ripudaman Singh of Nabha (1883–1942)*, ca. 1903

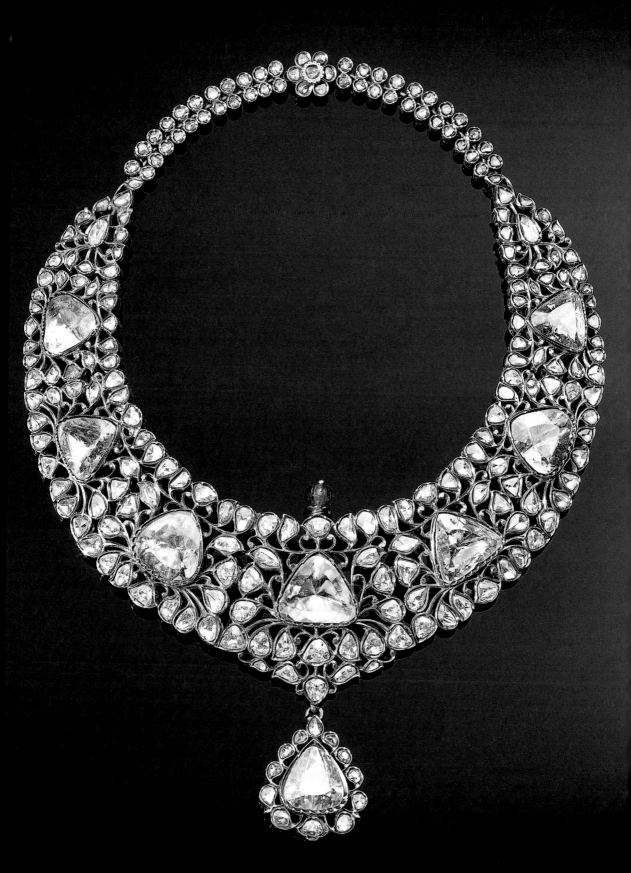

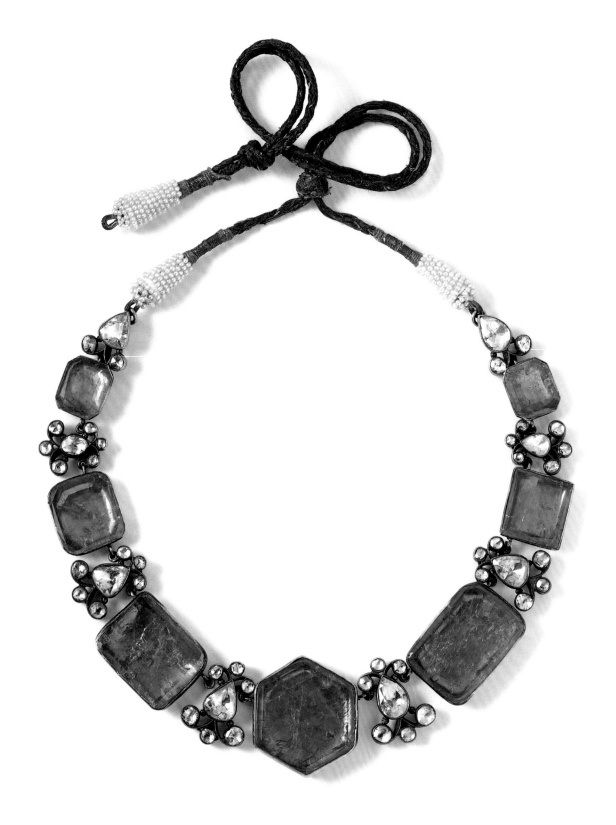

NECKLACE (*KANTHI*)

India, probably Hyderabad, 1850–1900

Gold, set with emeralds; silver, set with diamonds; with pearls and string

L. (excluding string) 12 1/4 in. (31 cm)

Obtained by gift, inheritance, or conquest, the finest gems in an Indian treasury were mounted into impressive jewelry for a ruler to wear in a durbar, a ceremonial public gathering. This necklace, to be worn by a prince, exemplifies the opulence of the court in the period of the Raj, as well as the hybrid nature of Indian jewelry design influenced by European taste. The arrangement of the gems, the absence of enameling on the reverse, and the design of the diamond clusters are all Western in inspiration, yet the necklace retains the traditional method of fastening by an adjustable cord, which is adorned with minuscule pearls.

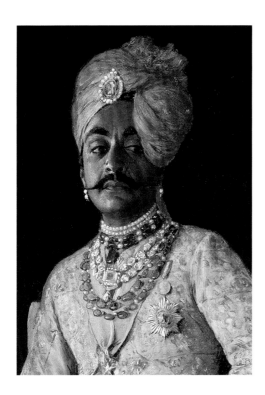

While exquisite on their own, necklaces were often worn en masse, in a variety of lengths, colors, and materials. Detail of Rudolf Swoboda, *Sir Pratap Singh (1845–1922)*, 1888

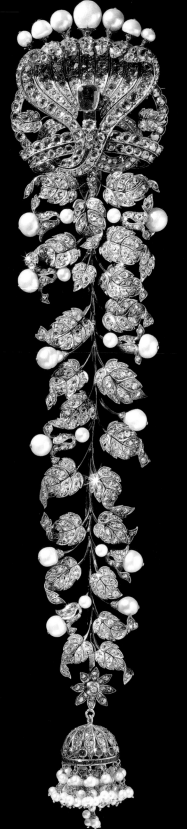

PLAIT ORNAMENT (JADANAGAM)

South India, 1890–1910

Silver, set with diamonds, rubies, and pearls

H. 12 1/4 in. (31 cm), W. 2 5/8 in. (6.6 cm)

A plait ornament, known as a *jadanagam*, was suspended
over a long braid of hair. The term *jadanagam* derives
from the Sanskrit *naga*, or cobra, a reference to both the
long, tapering form of the ornament and the expanded
"hood" of the upper section. In Hindu iconography
a multihooded cobra, often depicted over the head of
a deity, signifies protection. A cobra is frequently
shown coiled around the neck of Shiva, with whom it
is closely associated, and it is also portrayed above
the figure of a dancing Krishna (see p. 54).[38]

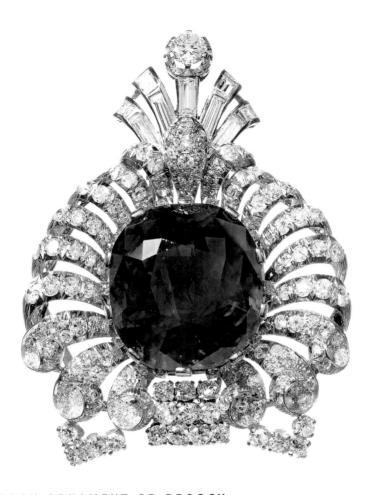

TURBAN ORNAMENT OR BROOCH

India, ca. 1920, modified ca. 1925–35

Platinum, set with sapphire and diamonds

H. 3 in. (7.5 cm), W. 2 ³/₈ in. (6 cm)

This jewel belonged to Maharaja Ranjitsinhji Vibhaji (r. 1907–33), who was the ruler of Nawanagar and a cricketing legend. The 109.5-carat sapphire at the center, surrounded by diamonds, is unusual in the context of Indian jewelry. In Hindu astrology, sapphires are associated with the planet Saturn (*shani*) and are thought to have the potential to be a malign force, rather than a favorable one. It is possible that Ranjitsinhji had determined that sapphires were an auspicious stone for him, especially given that the colors of the Sussex County Cricket Club, for which he began playing in 1895, are blue and white.

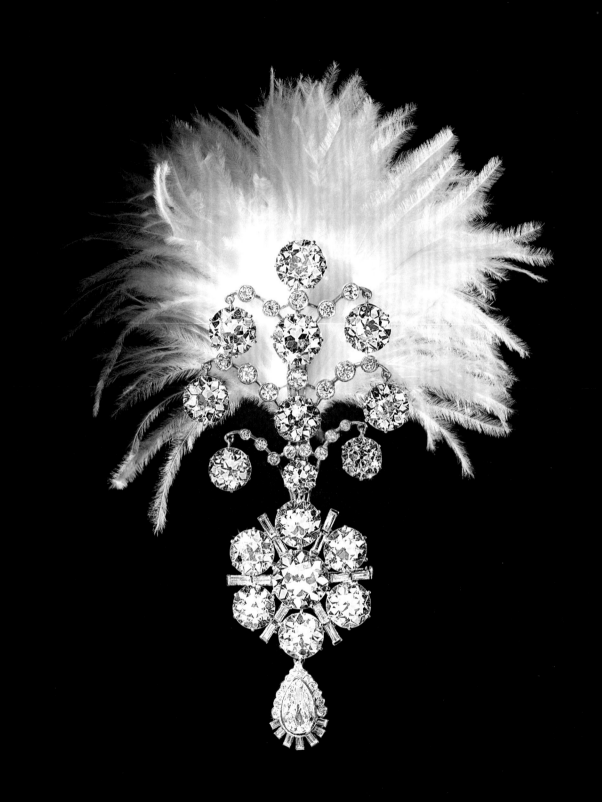

TURBAN ORNAMENT (*JIGHA*)

India, 1907, remodeled 1935

White gold, set with diamonds, with modern feather plume

H. 6 in. (15 cm), W. 2⅝ in. (6.5 cm)

This turban ornament (*jigha*) is a remodeled version of a jewel originally worn by Maharaja Ranjitsinhji Vibhaji, the ruler of Nawanagar.[39] The original *jigha* was composed of two detachable parts, a rosette and a spray, which Ranjitsinhji could mix with other elements of his jewelry collection. The piece was remodeled shortly after the accession of Ranjitsinhji's successor, his nephew Digvijaysinhji. The new ruler reset the diamonds in white gold, which enhanced their brilliance while maintaining the tradition of using gold, considered a sacred material by some Hindus, for royal jewelry. The recasting, most likely completed by a Nawanagar court jeweler, also entailed shortening the branching sprays of the diamonds.

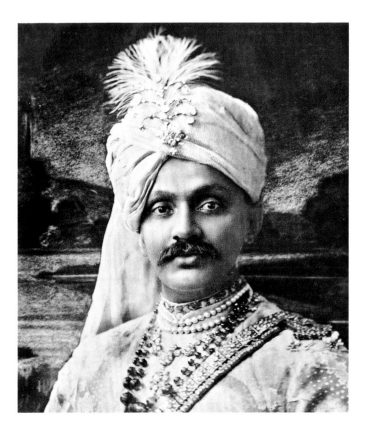

Maharaja Ranjitsinhji Vibhaji, Jam Sahib of Nawanagar, wears the *jigha* in its original configuration, before it was remodeled into its present form.

JEWELED CROWN

Nepal, ca. 1900

Pearls, colored glass, diamonds, emeralds, and rubies, with gold brocade ribs and
bird of paradise plumes; interior lined with red cloth

Overall: H. (with plume) 16⅛ in. (41 cm); cap: H. 6¼ in. (15.8 cm), Diam. 9½ in. (24 cm);
plaque: H. 7⅛ in. (18 cm), W. 4⅛ in. (10.5 cm)

The center of the diamond plaque on this richly embellished crown bears the coat of
arms of Nepal and the inscriptions "Honorable Government of Nepal" and "Mother
and Land of Birth are greater than Heaven," the latter a line from the Hindu epic the
Ramayana. This patriotic expression appropriately adorns a headdress designed to be
worn at public and religious events by the members of the male monarchy and
high-ranking government officials in Nepal, following traditions from the period
of the Rana dynasty (1846–1951).[40]

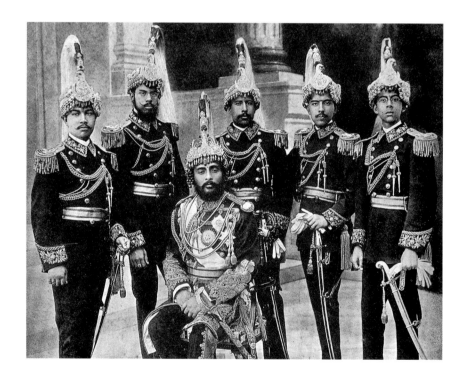

**Maharaja Chandra Shumshere, Prime Minister of Nepal (r. 1901–29),
with his sons, each of whom wears a version of this crown.**

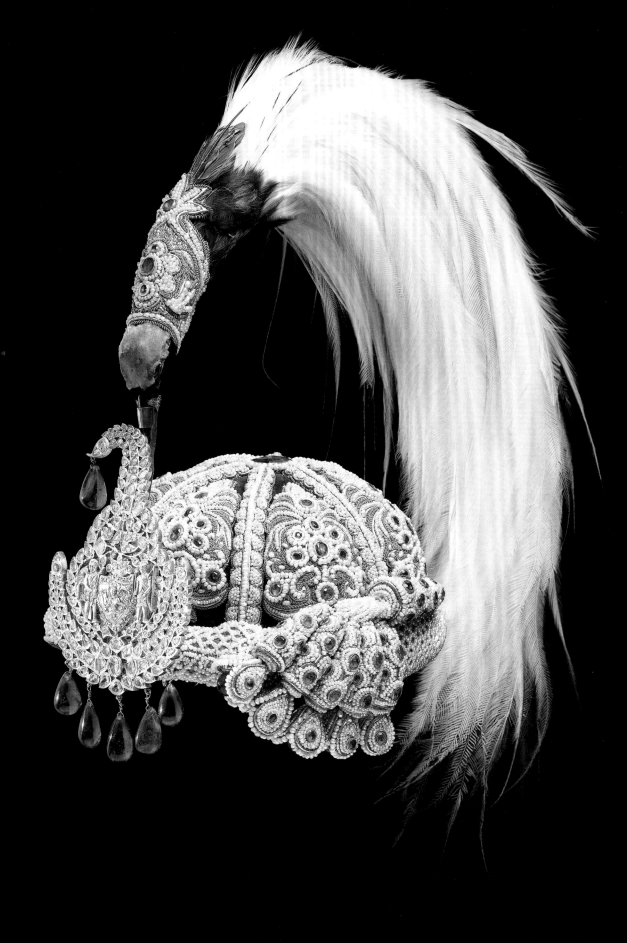

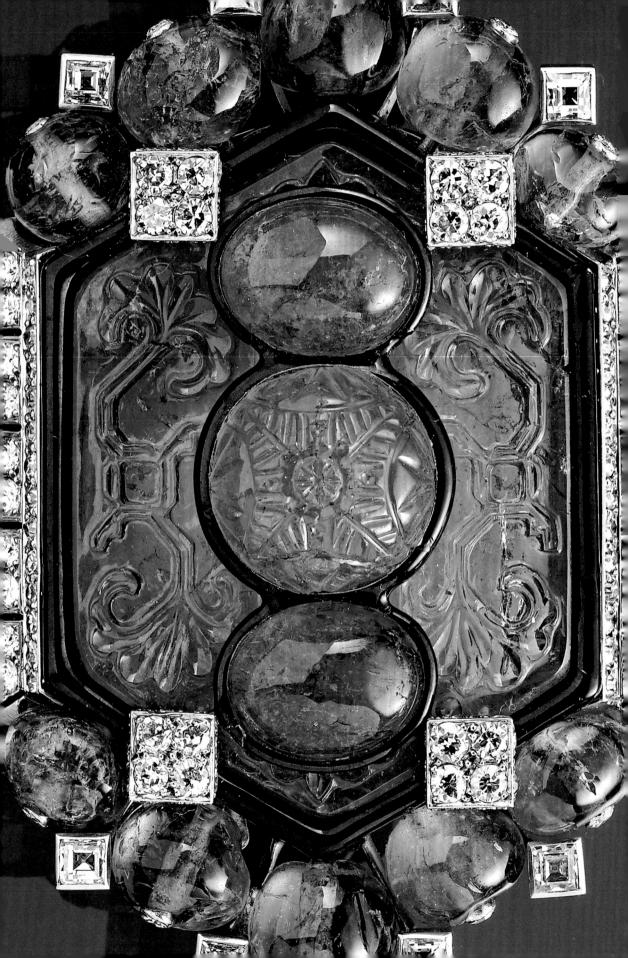

CARTIER *and*
WESTERN JEWELERS

Styles and motifs found in traditional Indian jewelry made an impact on Western jewelry designers, most famously on the house of Cartier, which was run by three brothers: Louis in Paris, Jacques in London, and Pierre in New York. At the turn of the twentieth century Indian princes became important patrons of the Cartier firm, commissioning it to redesign their antique and traditional jewelry with a modern sensibility. One of the most famous commissions of the age was the Maharaja of Patiala Necklace, created in 1928. Cartier's ruby choker made for the same patron is included in this section.

Jacques Cartier's trips to India and his work on its royal collections served as design inspiration at the firm, which borrowed from Indian forms and styles of gem cutting, shaping, and setting to fashion jewelry for the Western market. Cartier's own notable collection of historical jewels provided further stimulation, as Indian gems were reset into new designs. In 1913 Cartier New York held the exhibition "A Collection of Jewels . . . Created by Messieurs Cartier . . . from the Hindoo, Persian, Arab, Russian and Chinese," which exemplified the exotic tastes of the age. The firm's work in the 1920s and 1930s continued to make references to these stimuli, and European and North American tastes kept Indian-inspired jewels in demand, as demonstrated in creations such as the opulent "Hindu" ("Tutti Frutti") necklace made for the socialite Daisy Fellowes (p. 17). Shown in this section are a 1927 Cartier brooch and a related jewel derived from another celebrated necklace by the firm, the Collier Bérénice, featuring Indian carved emeralds.

AIGRETTE

France, Paris, designed by Paul Iribe, made by Robert Linzeler, 1910
Platinum, set with emerald, sapphires, diamonds, and pearls
H. 3 ⁵/₈ in. (9 cm), W. 2 ¹/₄ in. (5.6 cm), D. ⁵/₈ in. (1.5 cm)

Trained as an artist, Paul Iribe was perhaps best known as a costume and jewelry designer, whose creations were brought to life by the goldsmith Robert Linzeler. Here Iribe set a carved Indian gem into the form of an aigrette, which would have ornamented the turban of a maharaja or nizam. Two illustrations from the publication *Comœdia illustré* show the piece being worn as a *plaque de corsage* by the stage actress Jeanne Dirys, who was also Iribe's wife. This is the first known instance of a European jeweler incorporating an Indian emerald into a design.[41]

Actress Jeanne Dirys wears the jewel as a *plaque de corsage*.
Detail from the cover of *Comœdia illustré*, March 1, 1911

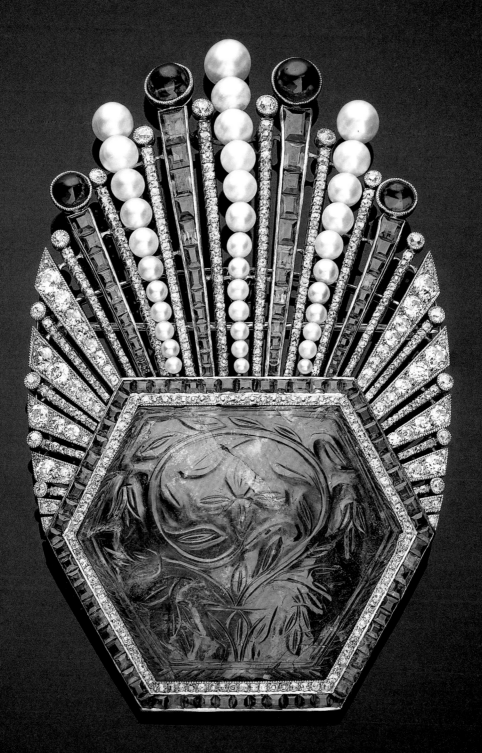

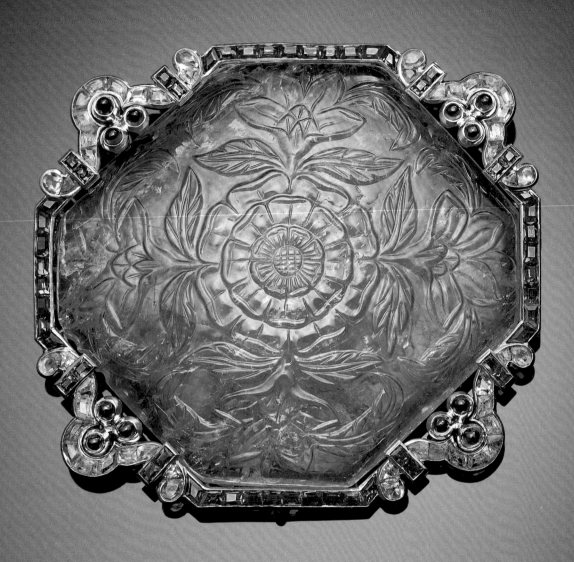

BROOCH

United States, New York, made by Cartier, ca. 1920
Platinum, set with sapphires and emeralds
H. 2 in. (5 cm), W. 2¼ in. (5.5 cm)
Promised gift to The Metropolitan Museum of Art, New York

Brothers Louis, Jacques, and Pierre Cartier were distinguished collectors of classical antiquities, Chinese jades, Persian manuscripts, and Indian emeralds. They not only used these private collections as inspiration for their work but also incorporated antique or exotic objects into modern gem-set jewelry. The emeralds favored by the Cartiers often date from the Mughal period; this octagonal example is carved with floral forms and mounted in a later border of sapphires and emeralds.

The maharani wears an Art Deco–style necklace with an emerald pendant. Detail of Bernard Boutet de Monvel, *Maharani Sanyogita Devi of Indore*, ca. 1931–38

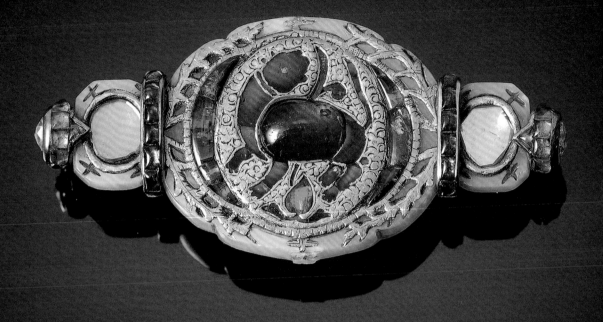

BROOCH

North India, Mughal, 1650–1750; mounts, France, Paris, made by Cartier, ca. 1930
Jade, inlaid with gold, rubies, emeralds, and diamonds
H. 1 in. (2.5 cm), W. 2¼ in. (5.7 cm)

Likely reworked from the main element of an older *bazuband* (upper-arm bracelet), this piece, bearing the figure of a lion, was converted to a brooch by Cartier in the 1930s. The reconfiguration included the addition of ruby-set collars around the side sections, as well as the end caps and the pin. The original piece may have been acquired by Jacques Cartier on his Indian travels or perhaps through one of the Indian dealers who supplied the firm with gems and old jewelry. This brooch was reputedly later in the collection of Colin Tennant, Lord Glenconner.

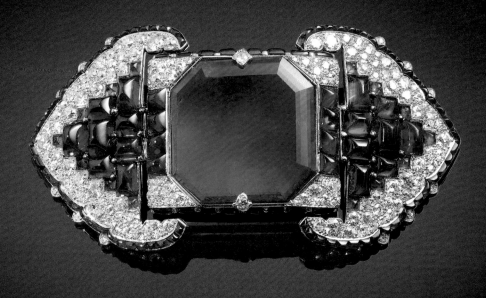

BELT BROOCH

France, Paris, made by Cartier, ca. 1920–30

Platinum, set with emeralds, sapphires, and diamonds

H. 1⅝ in. (4.2 cm), W. 3⅜ in. (8.5 cm); octagonal emerald: approx. 38.71 ct

Known as a *broche de ceinture*, this brooch was designed specifi-
cally to be worn on a fabric belt, slung low on a dropped-waist
dress, a fashion popular in the mid-1920s.[42] The geometric ele-
ments of the design reflect the era's Art Deco aesthetic, and yet
this piece is among a group of jewels whose designs are Indian
in inspiration. Cartier's designers would have been familiar
with the tradition of male royalty wearing jeweled belts,
which sometimes incorporate large stones into a central clasp.

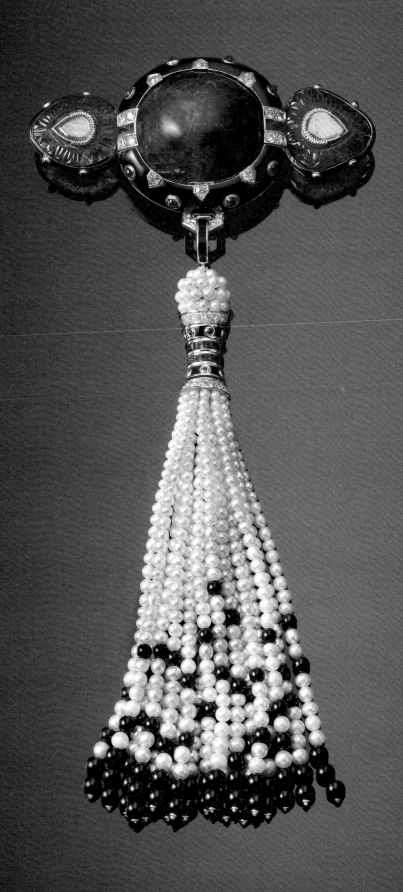

SHOULDER BROOCH

England, London, made by Cartier, 1924; pendant tassel re-created from original records
by Cartier workshops, Paris, 2012
Brooch: platinum, set with emeralds, rubies, diamonds, enamel, and gold; tassel:
pearls and onyx beads
Overall: H. (with tassel) approx. 6 1/8 in. (15.3 cm); brooch: H. 1 3/8 in. (3.3 cm), W. 2 3/4 in. (7 cm)

The shoulder brooch (*broche d'épaule*) was developed to adorn the lightweight shift
dress of the 1920s, whose fabric could not support a heavy jewel. The design of this
brooch, with its central circular stone and two smaller side elements, resembles
the main part of an Indian *bazuband*, or upper-arm bracelet. The pear-shaped diamonds
that flank the central emerald are set in the *kundan* technique, a nod to traditional
Indian jewelry. This is one of many Cartier shoulder brooches made with pearl and
onyx-bead tassels.[43] When fashions changed, the dangling elements were inevitably
removed and the stones reused, leaving a relatively small brooch that was easy to
wear on a bodice or a hat.

**Socialite and heiress Marjorie Merriweather Post was well known for her opulent
jewelry, much of which was designed by Cartier. In this portrait with her daughter
she wears an emerald Cartier shoulder brooch.** Detail of Giulio de Blass, *Portrait
of Mrs. Hutton and Nedenia Hutton*, 1929

ELEMENTS FROM A CARTIER EMERALD ENSEMBLE

France, Paris, made by Cartier, 1925; modified by Cartier in 1927

Platinum, set with emeralds, diamonds, and enamel

Brooch: H. 1¾ in. (4.4 cm), W. 2⅝ in. (6.7 cm); hexagonal emerald: approx. 88.03 ct; central carved cabochon emerald: approx. 15.65 ct

Emerald: H. 1⅝ in. (4 cm), W. 2⅛ in. (5.3 cm); 141.13 ct

This brooch and carved hexagonal emerald were showcased by Cartier at the Exposition Internationale des Arts Décoratifs et Industriels Modernes of 1925, held in Paris.[44] The exhibition, which presented the best of French design, highlighted modernity in the decorative arts. Cartier displayed three pieces on a single mannequin, including a tiara; a neck ornament known as the Collier Bérénice, of which this emerald was the centerpiece; and a *broche de corsage*, from which this smaller brooch was modified. The Collier Bérénice was draped across the shoulders and hung down the back at each side. In recent years the hexagonal gem has been called the Taj Mahal Emerald, as the carved floral motifs evoke the relief decoration seen in Mughal architecture.

A mannequin wears the original configuration of the brooch, along with the Collier Bérénice shoulder ornament and a tiara, at the Cartier display at the 1925 Exposition Internationale des Arts Décoratifs et Industriels Modernes.

This drawing illustrates the original 1925 design for the brooch, which included the hexagonal emerald flanked by pearl and diamond ornaments (later removed). The current orientation is altered ninety degrees from the original.

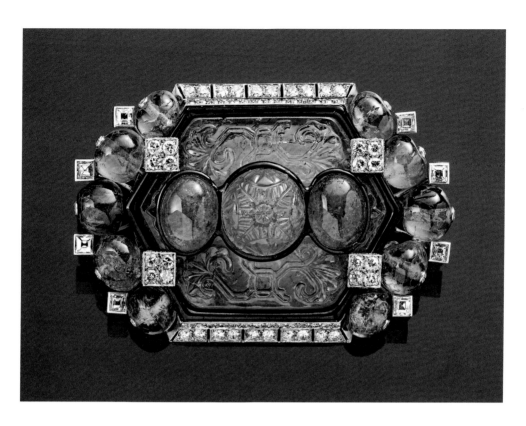

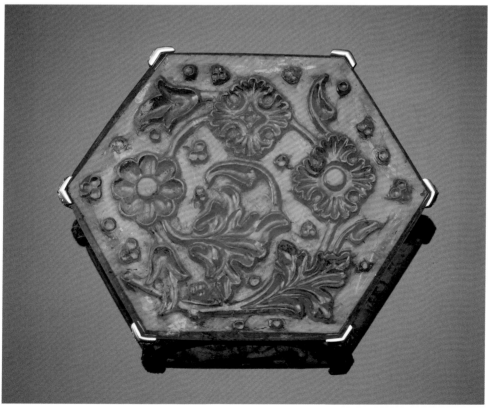

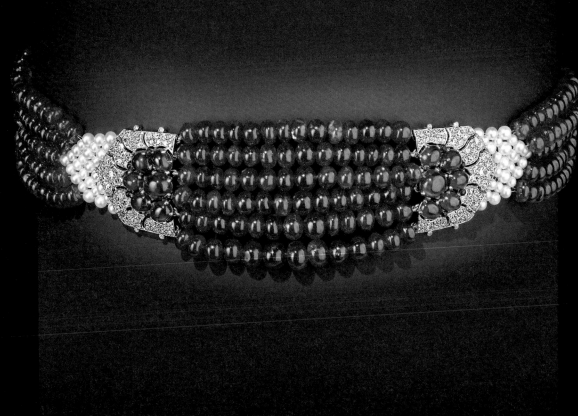

THE PATIALA RUBY CHOKER

France, Paris, made by Cartier, 1931; restored and restrung to the original design by Cartier Tradition, Geneva, 2012

Rubies, diamonds, and pearls, with platinum mounts

L. 13 ⅛ in. (33.3 cm), H. ⅞ in. (2.2 cm)

In the Indian jewelry tradition, the stones are more highly valued than their settings, and thus successive generations have had them reset as desired. In the 1920s and 1930s Maharaja Bhupindra Singh of Patiala (r. 1900–38) commissioned Cartier Paris to remodel pieces from his treasury, including the gems that make up this ruby, diamond, and pearl choker. Part of an ensemble of three necklaces, it is inspired by the form of the Indian *guluband*, a choker tied around the neck by cords, though its blocky geometric design also reflects the contemporaneous Art Deco style.

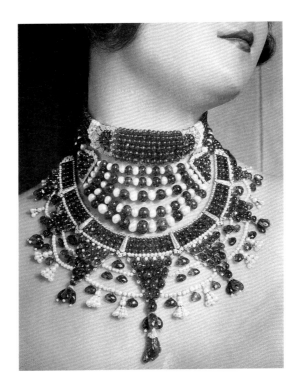

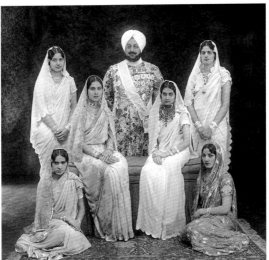

Top: **The Maharaja of Patiala Necklace is displayed on a Cartier wax mannequin, 1931.**

Bottom: **The maharani at center right, one of the wives of Sir Bhupindra Singh, maharaja of Patiala, wears the three Cartier necklaces, including the choker.** Detail of C. Vandyk, *Sir Bhupindra Singh, Maharaja of Patiala, with members of his family,* January 24, 1931

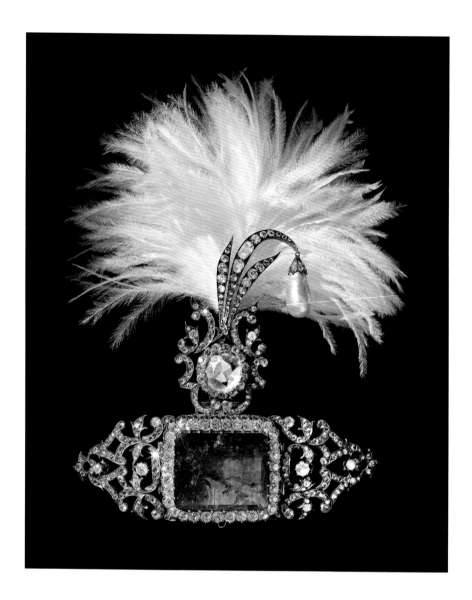

TURBAN ORNAMENT AND BROOCH (*SARPESH*)

Turban ornament, India, ca. 1900; clip on reverse made by Cartier Paris, 2012
Gold and silver, set with emerald and diamonds, with hanging pearl
H. 4 5/8 in. (11.7 cm), W. 5 1/8 in. (12.8 cm)

This piece is composed of two detachable parts: a jeweled, plume-shaped turban ornament (*jigha*) and a brooch, which takes the form of the main part in a *bazuband* (upper-arm ornament). The *jigha* was fashioned with open, clawlike gem settings, following European convention. Its combination with the brooch updates the piece to a full-size *sarpesh*, using contemporary design and gem setting to play on a historical aesthetic.

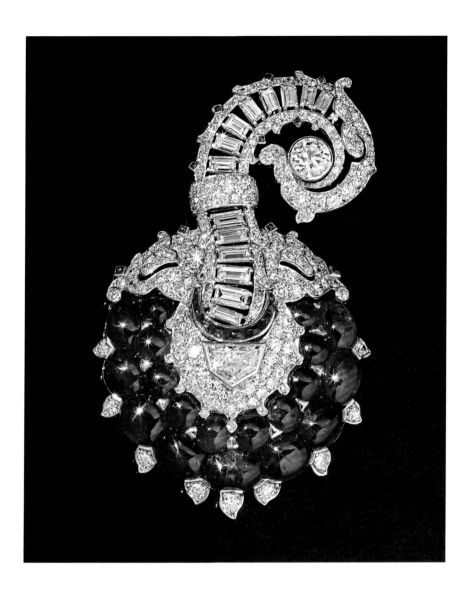

TURBAN ORNAMENT OR BROOCH

France (?), ca. 1935

Platinum, set with rubies and diamonds

H. 2 3/4 in. (6.9 cm), W. 1 5/8 in. (4.2 cm)

Echoing the form of a turban ornament, this brooch was designed with a mix of Indian, Chinese, and Western elements by an unknown firm, probably in France.[45] The coiling form at the top of the pin can be read as a dragon head, based on carved jades of the ancient Chinese Eastern Zhou dynasty—a motif utilized by Cartier in the 1920s and 1930s.[46] The kite-shaped diamond at the center, which also relates to work by Cartier, and the rectangular emerald-cut diamonds on the dragon form illustrate a trend toward geometric diamond cutting in the interwar years.[47]

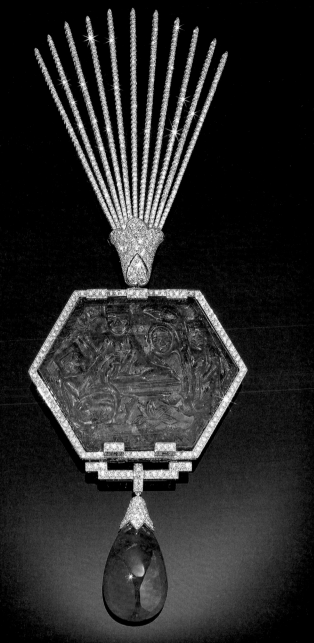

AIGRETTE

France, Paris, made by Cartier, 2012

Platinum, set with emeralds and diamonds

H. 7 ³/₄ in. (19.5 cm), W. 3 in. (7.4 cm)

The style of this contemporary aigrette, which incorporates a historical emerald carved in India, recalls earlier Indian *jigha* forms of Western inspiration. The hexagonal emerald bears a scene from the Hindu epic the *Ramayana* and includes the figures of Rama, Sita, and Hanuman. The reverse depicts a stylized flowering plant and a hatched border.

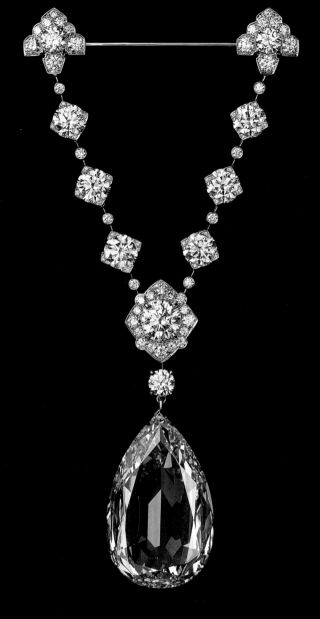

"STAR OF GOLCONDA" DIAMOND AND BROOCH

Diamond: India (?); brooch: France, Paris, made by Cartier, 2013
Platinum, set with diamonds
Diamond: H. 1¹/₂ in. (3.8 cm), W. 1 in. (2.4 cm), D. ³/₈ in. (0.7 cm); 57.31 ct
Brooch: H. 5¹/₈ in. (13 cm), W. 2⁵/₈ in. (6.5 cm)

The name that has been given to this diamond by Cartier alludes to mines in the
Indian kingdom of Golconda, the source of historically significant diamonds in
the fifteenth and sixteenth centuries. Although it cannot be determined whether
the stone is of Indian or African origin, the association with Golconda evokes some
of the oldest and finest diamonds in the world, such as the Koh-i-noor and Hope
diamonds. The Internally Flawless grade and good symmetry of this diamond
attest to its quality.

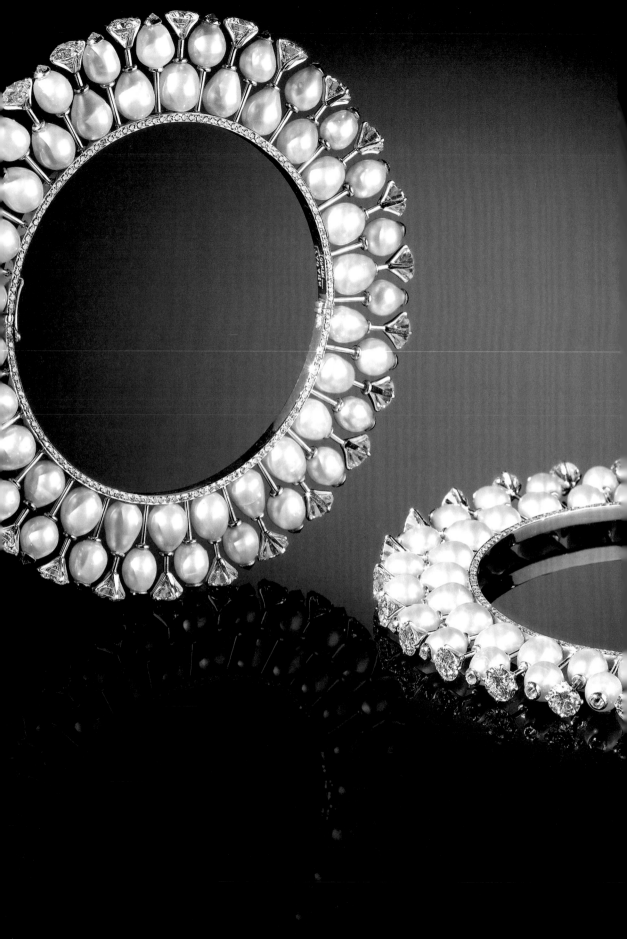

CONTEMPORARY CREATIONS

Jeweled objects in this section highlight contemporary styles inspired by Indian tradition. Included are the creations of two designers, Paris-based jeweler Joel Arthur Rosenthal, better known as JAR, and Bombay-based Viren Bhagat. In current practice, older gems are often reset into new designs, a variety of fresh objects is being introduced, and a wide interpretation of traditional forms is freely expressed.

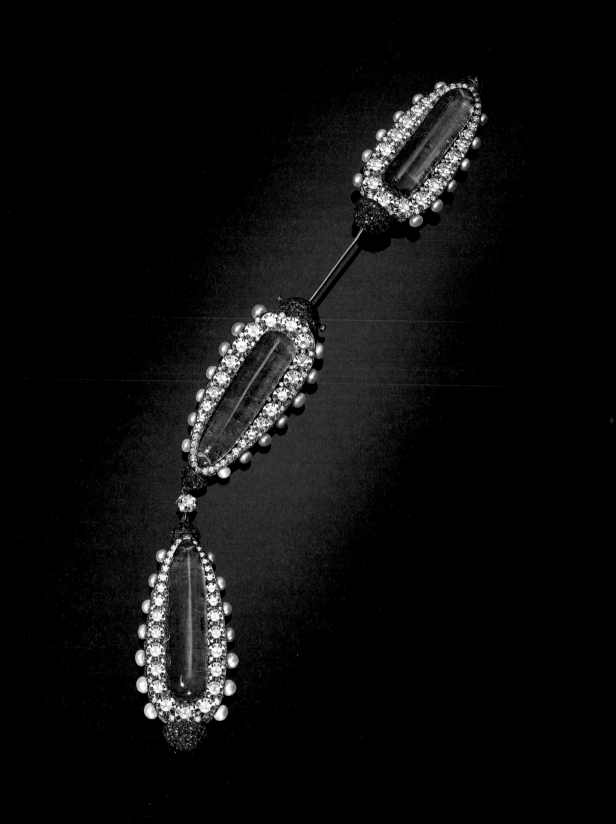

JABOT OR *CLIQUET* BROOCH

France, Paris, made by JAR, 2013

Silver and gold, set with emeralds, diamonds, pearls, and rubies

L. 7¾ in. (19.7 cm), W. 1¼ in. (3 cm); emeralds: 33.24 ct, 27.88 ct, 27.34 ct

Designed as a modern-day *jabot* or *cliquet*, French terms for a fashionable brooch type of the 1920s and 1930s, this long, slender ornament is composed of two detachable decorative elements, joined by a fine straight pin that is slipped through the garment and clicked into place. When fastened, the pin is invisible, and the two ornaments seem to float on the fabric as if unconnected. A similar form may have been worn by Indian nobility in centuries past. The oblong shape of these emeralds, inspired by turban ornaments, is unusual.

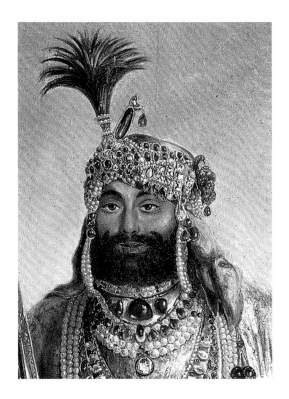

Maharaja Sher Singh wears in his turban an emerald ornament of similar elliptical shape. Detail of August Theodor Schoefft, *Maharaja Sher Singh (r. 1841–43)*

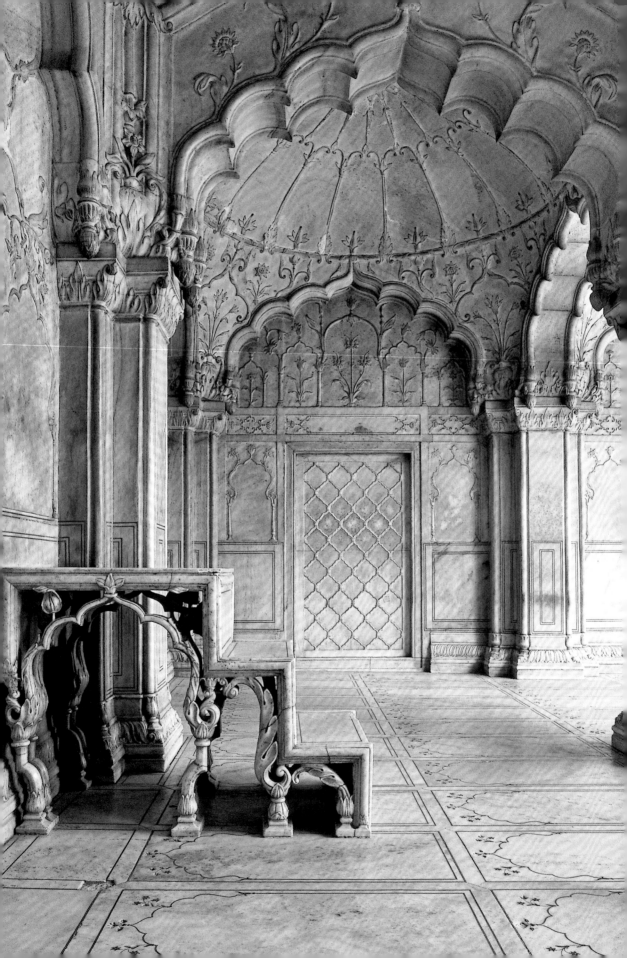

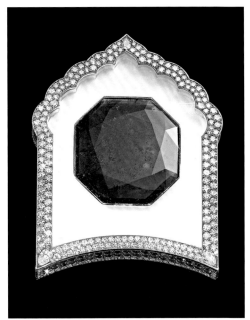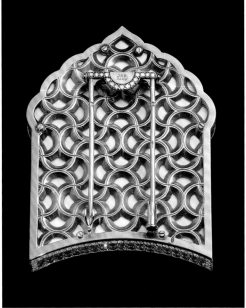

BROOCH

Front and back

France, Paris, made by JAR, 2002

Gold, set with emerald, diamonds, rubies, rock crystal, and white agate

H. 2 ¹/₂ in. (6.2 cm), W. 2 in. (4.9 cm), D. ³/₈ in. (0.9 cm); emerald: 35.36 ct

The lobed design at the top of this brooch recalls the cusped arches of Indian architecture. The link is further reinforced by the gold openwork on the reverse, resembling a *jali*, or pierced window screen.

Cusped arches appear throughout Mughal architecture, such as in the ceiling and floor decoration of the Moti Masjid ("Pearl Mosque") at the Delhi fort, built in 1659. A *jali*, carved in relief, is visible in the doorframe in the background. Photograph by Antonio Martinelli

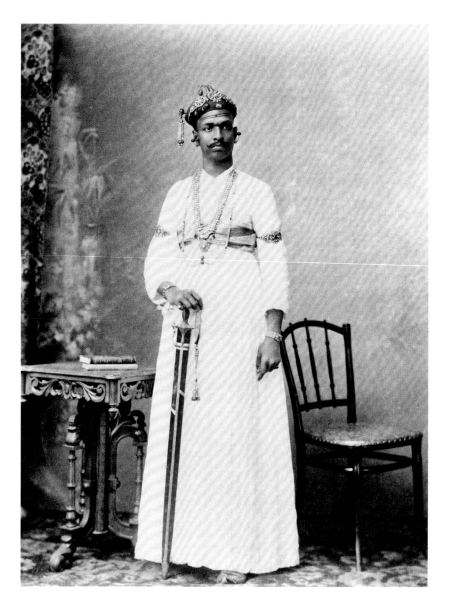

**Raja Rai Rayan Lakshmanraj Bahadur, a nobleman of
Hyderabad, wears a turban ornament with a long tassel.**
Detail of Lala Deen Dayal, *Prince, Hyderabad*, 1900

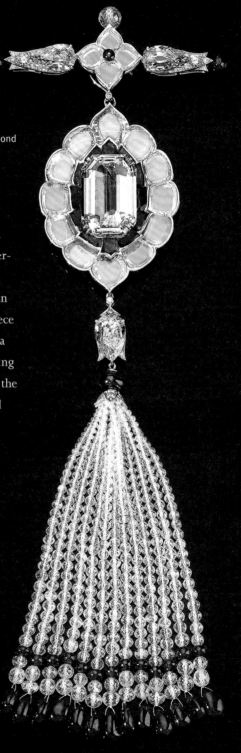

PENDANT BROOCH

India, Mumbai, made by Bhagat, 2011

Platinum, set with diamonds and rubies, with diamond and ruby beads

H. 7 ⅛ in. (18.1 cm), W. 2 ½ in. (6.4 cm); central diamond: 10.03 ct

The style of this modern pendant brooch suggests classic Mughal jewelry in its interpretation of floral forms and its tassel, which was an important feature of turban jewels and head ornaments. The centerpiece is a recently recut historical diamond. In a nod to the Indian tradition of ornamenting the back of jewelry, the designer adorned the reverse of the central emerald-cut diamond with a border of pavé diamonds.

PAIR OF BANGLES (*KADA*)

India, Mumbai, made by Bhagat, 2012
Platinum, set with diamonds and pearls
Each: Diam. 3 ³/₈ in. (8.6 cm)

A modern interpretation of the Indian *kada*, worn as a symbol of a woman's
marital status, these bangles contemporize one of the most traditional
forms of Indian jewelry (see p. 71). In particular, this pair is inspired by
Rajasthani bangles, which are worn in pairs on each arm. Here the designer
played with the traditional form of the guard bangle, which is the type
worn above and below several other bangles.

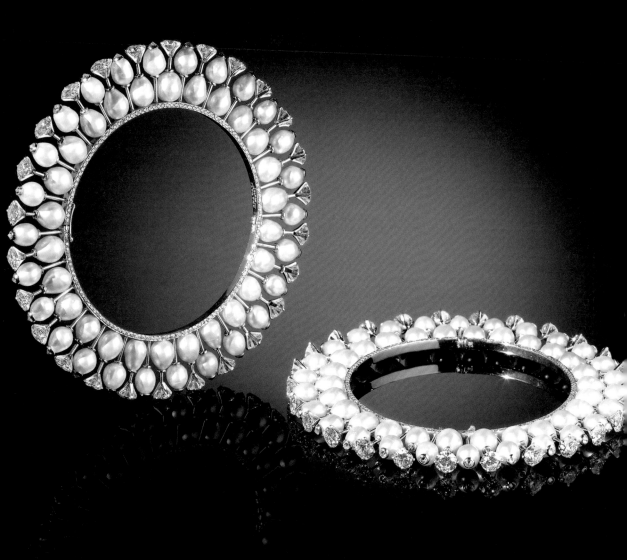

LIST OF ILLUSTRATIONS

Page 27: *Prince Salim*, folio from the Minto Album. By Bichitr, Mughal, India, ca. 1630. Opaque watercolor and gold on paper, 9⁷/₈ × 7¹/₈ in. (25 × 18.1 cm). Victoria and Albert Museum, London (IM.28-1925)

Page 29: *Jahangir Receives Prince Khurram, Ajmer, April 1616*, folio from the Windsor *Padshahnama*. Attributed to 'Abid, Mughal, India, 1635–36. Opaque watercolor and gold on paper, 14¹/₈ × 9¹/₂ in. (35.9 × 24.1 cm). Royal Collection Trust (RCIN 1005025, MS 1367, fol. 192b)

Page 30: *Mulla Shah Badakshi Sits in Meditation*, folio from the Shah Jahan Album. Mughal, India, 1627–28. Opaque watercolor on paper, 14³/₈ × 9³/₄ in. (36.5 × 24.6 cm). Art and History Trust Collection, Arthur M. Sackler Gallery, Smithsonian Institution, Washington, D.C. (LTS2002.2.4)

Page 32: *Jahangir Receiving Prince Khurram, on His Return from the Deccan*, folio from the Windsor *Padshahnama*. By Murar, Mughal, India, ca. 1640. Opaque watercolor and gold on paper, 12¹/₈ × 8¹/₄ in. (30.8 × 20.9 cm). Royal Collection Trust (RCIN 1005025, MS 1367, fol. 49a)

Page 35: *The Submission of Rana Amar Singh of Mewar to Prince Khurram*, folio from the Windsor *Padshahnama*. By La'lchand, Mughal, India, ca. 1640. Opaque watercolor and gold on paper, 12 ³/₄ × 8 ¹/₂ in. (32.4 × 21.6 cm). Royal Collection Trust (RCIN 1005025, MS 1367, fol. 46b)

Page 37: *Falcon*. By Mansur, Mughal, India, 17th century. Ink, opaque watercolor, and gold on paper, 15 ³/₈ × 10 ¹/₂ in. (39.1 × 26.7 cm). British Museum, London (1969,0317,0.2)

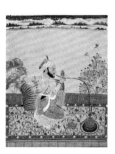

Page 39: *A Raja Smoking a Huqqa*. Kota, Rajasthan, India, ca. 1690–1710. Ink, opaque watercolor, and gold on paper, 6 ¹/₄ × 4 ⁵/₁₆ in. (15.9 × 11 cm). The Metropolitan Museum of Art, Gift of Wendy Findlay, 1981 (1981.371.2)

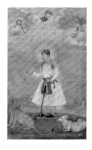

Page 43: *Akbar with Lion and Calf*, folio from the Shah Jahan Album. By Govardhan, Mughal, India, ca. 1630. Ink, opaque watercolor, and gold on paper, 15 ⁵/₁₆ × 10 ¹/₈ in. (38.9 × 25.7 cm). The Metropolitan Museum of Art, Purchase, Rogers Fund and The Kevorkian Foundation Gift, 1955 (55.121.10.22)

Page 44: *Shah Jahan on a Terrace, Holding a Pendant Set with His Portrait*, folio from the Shah Jahan Album. By Chitarman, Mughal, India, 1627–28. Ink, opaque watercolor, and gold on paper, 15 ⁵/₁₆ × 10 ¹/₈ in. (38.9 × 25.7 cm). The Metropolitan Museum of Art, Purchase, Rogers Fund and The Kevorkian Foundation Gift, 1955 (55.121.10.24)

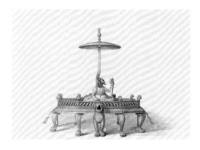

Page 46: Anna Tonelli (Italian, ca. 1763–1846). *Tipu Sahib, Sultan of Mysore (1749–1799), Enthroned*, 1800. Watercolor on paper, 15 ¹/₄ × 21 in. (38.5 × 53.2 cm). Powis Castle and Garden, National Trust, Wales (1180776)

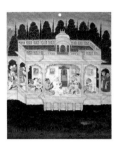

Page 53: *Maharana Sangram Singh Entertaining Maharaja Sawai Jai Singh of Jaipur at Jagmandir.* Udaipur, India, ca. 1728. Ink, opaque watercolor, and gold on paper. Private collection, London

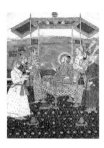

Page 59: *Muhammad Shah with Six Courtiers.* Kishangarh, India, ca. 1725. Opaque watercolor on paper, 12 1/2 × 9 1/2 in. (31.8 × 24 cm). Private collection, London

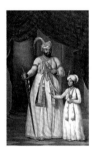

Page 61: Thomas Hickey (Irish, 1741–1824). *Azim ud-Dala, Nawab of Arcot, and His Son Azam Jah*, 1803. Oil on canvas, 93 × 57 1/8 in. (236 × 145 cm). Powis Castle and Garden, National Trust, Wales (1180953)

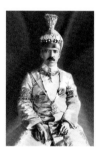

Page 62: Lala Deen Dayal (Indian, 1844–1910). *Wedding Portrait of Asaf Jah VII, Osman Ali Khan, Nizam of Hyderabad*, 1906. Archives of Foto Crafts, Vikas Chand Jain

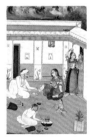

Page 69: *In a Goldsmith's Workshop.* Bundi, India, ca. 1760. Ink, opaque watercolor, and gold on paper, 9 3/4 × 6 1/2 in. (24.5 × 16.3 cm). The David Collection, Copenhagen (17/1981)

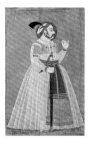

Page 72: *Maharana Amar Singh.* Udaipur, India, ca. 1735–40. Opaque watercolor on cotton cloth, 83 7/8 × 54 in. (213 × 137 cm). Victoria and Albert Museum, London, Purchased with the assistance of The Art Fund (IS.55-1997)

Page 75: *Sahebzadi Ahmed Unnisa and Sahebzada Salabath Jah, daughter and son of Asaf Jah VI, Mahbub Ali Khan, Nizam of Hyderabad*, ca. 1910. Chowmahalla Collection

Page 77: Ravi Varma (Indian, 1848–1906). *H. H. Janaki Subbamma Bai Sahib, Rani of Pudukkottai*, 1879. Oil on canvas, 52 5/8 × 40 in. (133.6 × 101.6 cm). Private collection

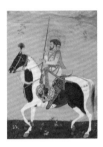

Page 80: *Shah Jahan on Horseback*, folio from the Shah Jahan Album. By Payag, Mughal, India, ca. 1630. Ink, opaque watercolor, and gold on paper, 15 5/16 × 10 1/8 in. (38.9 × 25.7 cm). The Metropolitan Museum of Art, Purchase, Rogers Fund and The Kevorkian Foundation Fund, 1955 (55.121.10.21)

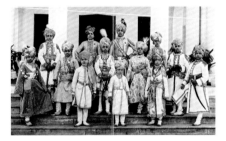

Page 82: Promod Kumar Chatterjee (Indian, 1885–1979). *Page Boys to King George V and Queen Mary*, 1911

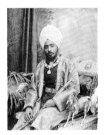

Page 86: *His Highness the Crown Prince Ripudaman Singh of Nabha (1883–1942)*. Calcutta, Bombay & Simla: Bourne & Shepherd (Indian studio, active 1864–1900s), ca. 1903. Platinum print. Royal Collection Trust (RCIN 291664)

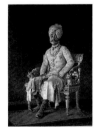

Page 89: Rudolf Swoboda (Austrian, 1859–1914). *Sir Pratap Singh (1845–1922)*, 1888. Oil on canvas, 22 1/2 × 15 5/8 in. (57.2 × 39.5 cm). Royal Collection Trust (RCIN 403600)

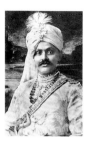

Page 93: *Maharaja Ranjitsinhji Vibhaji, Jam Sahib of Nawanagar*, date unknown. John Fasal Collection

Page 94: *Maharaja Chandra Shumshere, Prime Minister of Nepal (r. 1901–29), with his sons*, date unknown. Collection of Rajeev B. Shah

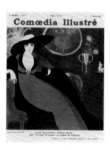

Page 98: Cover of *Comœdia illustré*, March 1, 1911

Page 101: Bernard Boutet de Monvel (French, 1881–1949). *Maharani Sanyogita Devi of Indore*, ca. 1931–38. Collection of Maharani Usha Devi of Indore

Page 105: Giulio de Blass (Italian, 1888–1934). *Portrait of Mrs. Hutton and Nedenia Hutton*, 1929. Oil on canvas, 59 ⅛ × 39 ⅛ in. (150 × 99 cm). Hillwood Estate, Museum & Gardens, Washington, D.C., Bequest of Marjorie Merriweather Post, 1973

Page 106 left: *Cartier display at the Exposition Internationale des Arts Décoratifs et Industriels Modernes*, 1925. Archives Cartier Paris

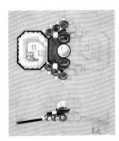

Page 106 right: *Design drawing for a Cartier brooch shown at the Paris Exposition*, 1925. Graphite, India ink, and gouache on tracing paper, 5$^7/_8$ × 5$^1/_8$ in. (14.8 × 12.8 cm). Archives Cartier Paris (ST25/05B)

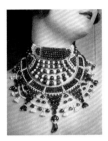

Page 109 top: *The Patiala Ruby and Pearl Necklace displayed on a Cartier wax mannequin*, 1931. Facsimile of an autochrome plate, 11$^7/_8$ × 9$^1/_2$ in. (30 × 24 cm). Archives Cartier Paris (Autochrome/49)

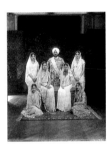

Page 109 bottom: C. Vandyk (British, active early 20th century). *Sir Bhupindra Singh, Maharaja of Patiala, with members of his family*, January 24, 1931. National Portrait Gallery, London (NPG x130952)

Page 117: August Theodor Schoefft (Hungarian, 1809–1888). *Maharaja Sher Singh (r. 1841–43)*. Private collection

Page 118: Moti Masjid ("Pearl Mosque") at the Delhi fort, 1659. Photograph by Antonio Martinelli

Page 120: Lala Deen Dayal (Indian, 1844–1910). *Prince, Hyderabad*, 1900

NOTES

Jewels of India in the Al-Thani Collection

1 Jaffer 2013.
2 Elgood 2004, pp. 83–84.
3 Ferishta 1981, pp. 188–89.
4 Meen and Tushingham 1968; Ivanov, Lukonin, and Smesova 1984. Other examples such as the famous Shah Diamond are in the State Diamond Fund, Armoury Chamber, Kremlin Museum, Moscow; see p. 23, fig. 6.
5 Keay 2011, pp. 156–59.
6 Jackson and Jaffer 2009.
7 Stronge 2009, pp. 18, 54. Ferishta 1981, p. 184, describes an early silver Bahmanid throne as surmounted with a bird of paradise above the canopy.
8 Tipu Sultan n.d., p. 72. In the eighteenth dream Tipu envisioned a horseman handing him emeralds the size of oranges.
9 Khalidi 1999, pp. 114–18, provides an account of the negotiations. Bala Krishnan 2001, pp. 28–37, provides more details, including photographs of objects that fell beyond the purview of the deal.
10 Salomé and Dalon 2013, pp. 204–7, explains the evolution of the necklace's design.
11 See Rudoe 1997, esp. pp. 157–87.
12 Halpern 2012, pp. 49–57.
13 Khalidi 1999, pp. 27–29.
14 Bharadwaj 2002, pp. 122–27, describes the modern diamond industry.
15 Markel 2004, pp. 68–75, outlines developments in Lucknow, the Punjab, and the Deccan.
16 James C. Y. Watt, "Bowl with bud handles," in Ekhtiar et al. 2011, pp. 368–69, no. 258.
17 Michael Spink and Robert Skelton, "Materials and Techniques in Indian Jewellery," in Jaffer 2013, pp. 384–87.
18 Keene 2004, pp. 99–126.
19 See Teng Shu-p'ing 2004.
20 Watt 1903, facing p. 478, pl. 75.
21 Khalidi 1999, p. 53. It is inscribed *burhan nizam shah 1000 hijri*, one of three royal inscriptions, the other two being added later by Shah Jahan and Fath 'Ali Shah in Iran.
22 Thanks are owed to Shiraz Vira for sharing this information and pictures of her bridal flowers.
23 Michael Spink and Robert Skelton, "Gems and Jewels in Mughal India, 1600–1739," in Jaffer 2013, p. 56.

Works in the Exhibition

1 Jaffer 2013, pp. 91–92, no. 4, points out that a painting of 1635 in the Windsor *Padshahnama* that shows Prince Khurram wearing a similar dagger might favor a reading of the regnal year on this blade as 9 rather than 2, which would correspond better to the date of the painting.
2 Skelton et al. 1982, p. 128, no. 406. It has also been suggested that it resembles the head of a "blackamoor," a motif frequently used in European decorative arts of the sixteenth and seventeenth centuries. Amin Jaffer, email to the author, February 5, 2014.
3 Jaffer 2013, pp. 92–93, no. 5.
4 Jahangir 1968, vol. 1, p. 286.
5 Okada 2000, p. 80.
6 Keene and Kaoukji 2001, p. 35, illustrates a similar box (LNS 369 HS). A comparable box is in the Metropolitan Museum (02.18.776a, b).
7 Watt 1903, facing p. 478, pl. 75.
8 Latif, Schotsmans, and Nolens 1982, p. 134–37; Tait 1986, p. 174.
9 Jaffer 2013, p. 107n33, points out similarly inscribed objects in the Hermitage collection, Saint Petersburg.
10 Stronge 2009, pp. 16–18.
11 The bird and the tiger's head are now in the Royal Collection.
12 Jaffer 2013, p. 199n161, lists the four known finials.
13 Buddle, Rohatgi, and Brown 1999, p. 67, pl. 90.
14 Keene and Kaoukji 2001, p. 38; Canby 2014, p. 45.
15 Nandagopal and Iyengar 1995, p. 40.
16 More fantastical uses of such spoons are depicted in Indian paintings. See Dallapiccola 2010, p. 114, no. 7.49.

Thanks are due to Pramod Kumar KG for pointing this out.

17 Buddle, Rohatgi, and Brown 1999, p. 26, pl. 28; Keene and Kaoukji 2001, pp. 108–9, illustrates comparable works (LNS 751 J, LNS 2003 J).

18 Keene and Kaoukji 2001, p. 108, illustrates a very similar object (LNS 28 J).

19 Prior and Adamson 2000, p. 40, summarizes the prevailing arguments.

20 Musta'id Khan 1947, p. 80.

21 Carvalho, Cockrell, and Vernoit 2010, p. 182.

22 Prior and Adamson 2000, p. 38.

23 Bala Krishnan 2001, p. 97.

24 Email from Michael Spink to Amin Jaffer, June 16, 2014.

25 Bala Krishnan 2001, pp. 92, 96–97; Bala Krishnan and Kumar 1999, p. 217; Untracht 1997, p. 383. However, diamond drop beads also appear in a necklace on p. 106 and a ruby sarpesh on p. 94 in Bala Krishnan 2001. Thanks are due to Michael Spink for providing descriptions of this object and the comparative pieces.

26 Untracht 1997, pp. 328–29.

27 Bala Krishnan 2001, pp. 110 and 140, respectively. Thanks are due to Michael Spink for providing descriptions of this object and the comparative pieces.

28 Untracht 1997, p. 275, pl. 657.

29 Bala Krishnan and Kumar 1999, p. 205; and Bala Krishnan 2001, pp. 188–89, 199.

30 Untracht 1997, pp. 172–73.

31 Rai Krishnadasa, "The Pink Enamelling of Banaras," in Anand Krishna 1971, pp. 327–34.

32 Untracht 1997, p. 191.

33 Abu'l-Fazl Ibn Mubarak 2001, vol. 3, p. 344.

34 Keene and Kaoukji 2001, p. 22, reproduces a similar piece (LNS 753 J).

35 Untracht 1997, p. 78.

36 Jaffer 2013, p. 273, no. 94.

37 Bala Krishnan 2001, p. 152.

38 Untracht 1997, pp. 48–51.

39 See Wild 1934, pls. facing pp. 72, 112, 224.

40 Rana et al. 2003, pp. 34–35, 43, 216. Vernoit 1997, pp. 140–41, reproduces a similar crown in the Nasser D. Khalili collection.

41 Amin Jaffer, email to Navina Najat Haidar, February 5, 2014.

42 Rudoe 1997, p. 246, no. 181. See also "Fashion: A Jewel Song from Paris," *Vogue* 72, no. 12 (December 8, 1928), p. 76.

43 Rudoe 1997, pp. 312–13, nos. 261–65, and p. 324, no. 280.

44 Ibid., pp. 316–19.

45 Jaffer 2013, p. 323, no. 115: "The appearance of the 'Or' mark on the white gold pin suggests that this is a French-made piece, but in the absence of a signature or other documentation it is not possible to attribute it to a particular firm."

46 Rudoe 1997, p. 228, no. 159.

47 Jaffer 2013, p. 324n72, cites an example from 1936 with the same kite cut in the British Museum (P&E 2001,0505.7).

PUBLICATION RECORD

References are listed in chronological order within each object's entry. Full publication data is included in the bibliography on pages 134–38.

Dagger (*kard*) with European Head (p. 26)
Ellliott and Snowden 1974, no. 1; Skelton et al. 1982, p. 128; Welch 1985, pp. 202–3; Ricketts and Missillier 1988, pp. 93, 182, no. 149; Haider 1991, p. 212; Elgood 2004, pp. 83–85, fig. 9; Jaffer 2013, pp. 91–92, no. 4.

Dagger (*kard*) (p. 28)
Christie's London 2012, Lot 229, pp. 228–30; Jaffer 2013, p. 92, no. 5.

Crutch Handle (*zafar takiya*) (p. 31)
Skelton et al. 1982, pp. 119–20, no. 359; Sotheby's London 2008, Lot 179, p. 225; Simon Ray 2009, pp. 32–33, no. 10; Jaffer 2013, pp. 99–100, no. 25.

Flask (p. 33)
Jaffer 2013, pp. 92–93, no. 7.

Fly Whisk Holder (*chauri*) (p. 34)
Jaffer 2013, p. 100, no. 28.

Box (*dibbi*) (p. 36)
Jaffer 2013, p. 185, no. 46.

Pair of Falcon Anklets (p. 37)
Jaffer 2013, p. 186, no. 49.

Base of a Water Pipe (*huqqa*) (p. 38)
Watt 1903, facing p. 478, pl. 75; Jaffer 2013, p. 184, no. 43.

Two Huqqa Mouthpieces (*mohnal*) (p. 39)
Jaffer 2013, pp. 184–85, nos. 44–45.

Locket Pendant (p. 45)
Jaffer 2013, p. 91, no. 3.

Finial from the Throne of Tipu Sultan (p. 47)
Bonhams 2009, Lot 212; Stronge 2009, p. 17; Jaffer 2013, pp. 189–90, no. 61.

Tipu Sultan's Magic Box (p. 48)
Christie, Manson & Woods 1989, Lot 183, p. 105; Buddle, Rohatgi, and Brown 1999, p. 67, pl. 90; Moienuddin 2000, p. 133; Sotheby's London 2005, Lot 65, pp. 8–11; Jaffer 2013, p. 190, no. 62.

Ornament in the Shape of a *Makara* Head (p. 49)
Jaffer 2013, p. 189, no. 60.

Pen Case and Inkwell (*davat-i daulat*) (p. 50)
Jackson and Jaffer 2009, p. 142, no. 116; Jaffer 2013, p. 90, no. 1.

Rosewater Sprinkler (*gulabpash*) (p. 51)
Habsburg Feldman 1987, Lot 24, pp. 44–45, back cover; Christie's London 2010, Lot 47, p. 51; Jaffer 2013, p. 106, no. 41.

Bird-Shaped Ornament or Finial (p. 52)
Jaffer 2013, pp. 191–92, no. 66.

Bird-Shaped Pendant (p. 53)
Bonhams 2011, Lot 263, pp. 188–89; Jaffer 2013, pp. 187–88, no. 56.

Ritual Spoon (*uddharane*) (p. 54)
Jaffer 2013, p. 191, no. 63.

Dagger with a *Yali* Hilt (p. 55)
Jaffer 2013, p. 191, no. 65.

Turban Ornament (*jigha*) (pp. 58–59)
Jaffer 2013, p. 104, no. 33.

Turban Ornament (*jigha*) (p. 60)
Jaffer 2013, p. 104, no. 34.

Elephant-Shaped Turban Ornament (*jigha*) (p. 61)
Jaffer 2013, p. 189, no. 59.

Turban Ornament (*sarpesh*) (pp. 62–63)
Jaffer 2013, p. 194, no. 72.

Turban Ornament (*sarpesh*) (p. 66)
Jaffer 2013, p. 271, no. 89.

Pair of Anklets (p. 68)
Jaffer 2013, pp. 195–96, no. 77.

Anklet (*dastband almas*) (p. 70)
Christie's London 1997, Lot 309, p. 20; Jaffer
 2013, p. 198, no. 85.

Pair of Bangles (*kada*) (p. 71)
Jackson and Jaffer 2009, p. 120, no. 99; Jaffer
 2013, p. 195, no. 76.

Bracelet (p. 72)
Jackson and Jaffer 2009, p. 153, no. 126; Jaffer
 2013, p. 195, no. 74.

Pair of Bracelets (p. 73)
Jaffer 2013, p. 195, no. 75.

Forehead or Turban Ornament (*tika*) (pp. 74–75)
 Jaffer 2013, pp. 196–97, no. 81.

Two Nose Rings (*nath*) (p. 76)
Top (ruby): Christie's London 1997, Lot 335, p. 42.
Both objects: Jaffer 2013, p. 276, nos. 105–6.

Pair of Earrings (*pankhiyan*) (p. 78)
Jaffer 2013, p. 274, no. 98.

Seal Ring with Hidden Key (p. 79)
Jaffer 2013, pp. 273–74, no. 96.

Upper-Arm Ornament (*bazuband*) (p. 81)
Jaffer 2013, p. 196, no. 78.

Jeweled Buckle and Slide on Silk Sash (p. 83)
Jaffer 2013, p. 272, no. 93.

Ceremonial Sword (pp. 84–85)
Christie's London 1999, Lot 196, p. 87; Jaffer
 2013, p. 273, no. 94.

Necklace (*kanthi*) (p. 87)
Jaffer 2013, pp. 270–71, no. 87.

Necklace (*kanthi*) (p. 88)
Jaffer 2013, p. 271, no. 88.

Plait Ornament (*jadanagam*) (p. 90)
Jaffer 2013, pp. 274–75, no. 101.

Turban Ornament or Brooch (p. 91)
Jaffer 2013, p. 276, no. 104.

Turban Ornament (*jigha*) (p. 92)
Wild 1934, pls. facing pp. 72, 112, 224; Christie's
 Geneva 2010, Lot 292, pp. 208–9; Jaffer
 2013, p. 275, no. 103.

Jeweled Crown (p. 95)
Jaffer 2013, pp. 271–72, no. 91.

Aigrette (p. 99)
Comœdia illustré, March 1911 and February 1912;
 Bachollet, Bordet, and Lelieur 1982, p. 229;
 Nadelhoffer 1984, p. 187; Jaffer 2013,
 p. 318, no. 108.

Brooch (p. 100)
Sotheby's New York 2012, Lot 428, pp. 138–39;
 Jaffer 2013, pp. 318–19, no. 109.

Brooch (p. 102)
Sotheby's London 2010, Lot 189, pp. 291–93;
 Jaffer 2013, p. 321, no. 113.

Belt Brooch (p. 103)
Chapman 2009, pp. 72, 162, no. 63; Jaffer 2013,
 pp. 319–20, no. 110; Salomé and Dalon
 2013, p. 153, no. 192.

Shoulder Brooch (p. 104)
Sotheby's New York 2010, Lot 464, pp. 284–85;
 Jaffer 2013, p. 320, no. 111; Salomé and
 Dalon 2013, p. 153, no. 193.

Elements from a Cartier Emerald Ensemble (p. 107)
Brooch: Nadelhoffer 1984, pp. 184, 190–92;
 Cartier 1989, p. 137, nos. 253, 255; Chazal
 et al. 1995, pp. 144, 365, 391; Cologni and
 Nussbaum 1995, p. 30; Rudoe 1997,
 pp. 288–89, 316–19, no. 270; Fornas et al.
 2007, pp. 36, 38–39; Chapman 2009, p. 67;
 Chaille 2013, p. 12; Jaffer 2013, pp. 320–21,
 no. 112; Salomé and Dalon 2013, p. 223,
 no. 308; India 2014, p. 293.
Emerald: *Gazette du Bon Ton* 1925, insert;
 Nadelhoffer 1984, pp. 184, 190–92; Cartier
 1989, p. 137, nos. 253, 255; Pal 1989, p. 141,
 fig. 143; Dehejia 1997, p. 331, no. 213; Rudoe
 1997, pp. 316–19, no. 269; Untracht 1997,
 p. 330, no. 746; Bala Krishnan and Kumar
 1999, p. 46, no. 45; Zucker 2000, p. 26;
 Zucker 2002, pp. 43, 57, 59, 65, 131, 135,
 157, 159, 163, 166–67, 237; Chapman 2009,
 p. 67; Christie's New York 2009, Lot 1187,

pp. 172–73; Chaille 2013, p. 12; Jaffer 2013, pp. 95–96, no. 14; Salomé and Dalon 2013, pp. 162–65, no. 215; India 2014, pp. 236, 292.

The Patiala Ruby Choker (p. 108)
Christie's Geneva 2000, Lot 417, p. 22; Jaffer 2006, pp. 76–77; Jaffer 2013, pp. 322–23, no. 114; Salomé and Dalon 2013, pp. 300–301, no. 437; India 2014, pp. 278, 303.

Turban Ornament and Brooch (sarpesh) (p. 110)
Jaffer 2013, p. 274, no. 97.

Turban Ornament or Brooch (p. 111)
Christie's Geneva 2009, Lot 44, p. 29; Jaffer 2013, p. 323, no. 115.

Aigrette (p. 112)
Latif, Schotsmans, and Nolens 1982, p. 140;

Christie's London 2005, Lot 168, p. 174–75; Christie's New York 2010, Lot 43, p. 36; Jaffer 2013, p. 346, no. 124.

"Star of Golconda" Diamond and Brooch (p. 113)
Jaffer 2013, p. 381, no. 126.

Jabot or Cliquet Brooch (p. 116)
Jaffer 2013, p. 344, no. 118.

Brooch (p. 119)
Jaffer 2013, p. 344, no. 116; Sassoon and Rosenthal 2013, no. 8.

Pendant Brooch (p. 121)
Jaffer 2013, pp. 344–45, no. 119.

Pair of Bangles (kada) (p. 122)
Jaffer 2013, p. 345, no. 122.

SELECTED BIBLIOGRAPHY

Books and Articles

Abu'l-Fazl Ibn Mubarak 2001
Abu'l-Fazl Ibn Mubarak. *The A'in-i Akbari*. Ed.
 D. C. Phillott. Trans. H. Blochmann and
 H. S. Jarrett. 3 vols. 1927–49. Reprint.
 Delhi: Low Price Publications, 2001.

Aitken 2005
Aitken, Molly Emma. *When Gold Blossoms: Indian
 Jewelry from the Susan L. Beningson Collection*. Exh.
 cat. New York: Asia Society, 2005.

Bachollet, Bordet, and Lelieur 1982
Bachollet, Raymond, Daniel Bordet, and Anne-
 Claude Lelieur. *Paul Iribe*. Paris: Denoël, 1982.

Bala Krishnan 2001
Bala Krishnan, Usha R. *Jewels of the Nizams*. New
 Delhi: Department of Culture, Government
 of India, in association with India Book
 House, 2001.

Bala Krishnan and Kumar 1999
Bala Krishnan, Usha R., and Meera Sushil Kumar.
 Dance of the Peacock: Jewellery Traditions of India.
 Mumbai: India Book House, 1999.

Bharadwaj 2002
Bharadwaj, Monisha. *Great Diamonds of India*.
 Bombay: India Book House; Woodbridge,
 N.J.: Antique Collectors' Club, 2002.

Brij Bhushan 1955
Brij Bhushan, Jamila. *Indian Jewellery, Ornaments and
 Decorative Designs*. Bombay: Taraporevala, 1955.

Brij Bhushan 1979
Brij Bhushan, Jamila. *Masterpieces of Indian Jewellery*.
 Bombay: Taraporevala, 1979.

Buddle, Rohatgi, and Brown 1999
Buddle, Anne, Pauline Rohatgi, and Iain Gordon
 Brown. *The Tiger and the Thistle: Tipu Sultan and
 the Scots in India, 1760–1800*. Exh. cat.
 Edinburgh: Trustees of National Gallery of
 Scotland, 1999.

Canby 2014
Canby, Sheila R. *The Shahnama of Shah Tahmasp: The
 Persian Book of Kings*. New York: The
 Metropolitan Museum of Art, 2014.

Cartier 1989
*The Art of Cartier: Musée du Petit-Palais, October 20,
 1989–January 28, 1990*. Exh. cat. Paris: Musée
 du Petit Palais, 1989.

Carvalho, Cockrell, and Vernoit 2010
Carvalho, Pedro de Moura, Henrietta Sharp
 Cockrell, and Stephen Vernoit. *Gems and
 Jewels of Mughal India: Jewelled and Enamelled Objects
 from the 16th to 20th Centuries*. London: Nour
 Foundation, 2010.

Chaille 2013
Chaille, François. *High Jewelry and Precious Objects
 by Cartier: The Odyssey of a Style*. Paris:
 Flammarion, 2013.

Chapman 2009
Chapman, Martin. *Cartier and America*. Exh. cat. San
 Francisco: Fine Arts Museums of San
 Francisco; Munich: DelMonico Books/
 Prestel, 2009.

Chazal et al. 1995
Chazal, Martine, et al. *The World of French Jewelry
 Art: The Art of Cartier*. Exh. cat. Tokyo: Tokyo
 Metropolitan Teien Art Museum, 1995.

Cologni and Nussbaum 1995
Cologni, Franco, and Eric Nussbaum. *Cartier: Le
 Joaillier du platine*. Paris: Bibliothèque des Arts,
 1995.

Comœdia illustré, March 1911 and February 1912.

Dallapiccola 2010
Dallapiccola, Anna L. *South Indian Paintings:
 A Catalogue of the British Museum Collection*.
 London: British Museum Press, 2010.

Dehejia 1997
Dehejia, Vidya. *Indian Art*. London: Phaidon, 1997.

Ekhtiar et al. 2011
Ekhtiar, Maryam, et al., ed. *Masterpieces from the Department of Islamic Art in The Metropolitan Museum of Art.* New York: The Metropolitan Museum of Art, 2011.

Elgood 2004
Elgood, Robert. "Mughal Arms and the Indian Court Tradition." In *Jewelled Arts of Mughal India: Papers of the Conference Held Jointly by the British Museum and the Society of Jewellery Historians at the British Museum, London, in 2001.* Ed. Beatriz Chadour-Sampson and Nigel Israel. London: Society of Jewellery Historians, 2004.

Ferishta 1981
Ferishta, Mahomed Kasim. *History of the Rise of the Mahomedan Power in India: Till the Year A.D. 1612.* Trans. John Briggs, 1829. Reprint. New Delhi: Oriental Books, 1981.

Fornas et al. 2007
Fornas, Bernard, et al. *Cartier: Innovation through the 20th Century.* Moscow: Moscow Kremlin Museums, 2007.

Gazette du Bon Ton 1925
"Le Pavillon de l'élégance: L'Exposition des arts décoratifs et industriels modernes." Special issue. *La Gazette du Bon Ton*, no. 10 (1925).

Haider 1991
Haider, Syed Z. *Islamic Arms and Armour of Muslim India.* Lahore: Bahadur Publishers, 1991.

Halpern 2012
Halpern, Jake. "The Secret of the Temple." *The New Yorker*, April 30, 2012, pp. 49–57.

India 2014
Gosudarstvennye muzei Moskovskogo Kremlia. *India: Jewels That Enchanted the World.* Exh. cat. London: Indo-Russian Jewellery Foundation, 2014.

Ivanov, Lukonin, and Smesova 1984
Ivanov, A. A., V. G. Lukonin, and L. S. Smesova. *Oriental Jewellery from the Collection of the Special Treasury and State Hermitage Oriental Department.* Moscow, 1984.

Jackson and Jaffer 2009
Jackson, Anna, and Amin Jaffer, eds. *Maharaja: The Splendour of India's Royal Courts.* Exh. cat. London: V&A Publishing; New York: Harry N. Abrams, 2009.

Jaffer 2006
Jaffer, Amin. *Made for Maharajas: A Design Diary of Princely India.* London: New Holland Publishers, 2006.

Jaffer 2013
Jaffer, Amin, ed. *Beyond Extravagance: A Royal Collection of Gems and Jewels.* Essays by Vivienne Becker, Amin Jaffer, Jack Ogden, Katherine Prior, Judy Rudoe, Robert Skelton, Michael Spink, and Stephen Vernoit. New York: Assouline, 2013.

Jahangir 1968
Jahangir. *The Tuzuk-i-Jahangiri; Or, Memoirs of Jahangir.* Ed. Henry Beveridge. Trans. Alexander Rogers. 2 vols. 1909–14. Reprint. Delhi: Munshiram Manoharlal, 1968.

Keay 2011
Keay, Anna. *The Crown Jewels.* New York: Thames & Hudson, 2011.

Keene 2004
Keene, Manuel. "The Enamel Road, from Siena, Paris, London and Lisbon, Leads to Lucknow." *Jewellery Studies* 10 (2004), pp. 99–126.

Keene and Kaoukji 2001
Keene, Manuel, and Salam Kaoukji. *Treasury of the World: Jeweled Arts of India in the Age of the Mughals—The Al-Sabah Collection.* Exh. cat. New York: Thames & Hudson, 2001.

Khalidi 1999
Khalidi, Omar. *Romance of the Golconda Diamonds.* Middletown, N.J.: Grantha Corporation; Ahmadabad: Mapin Publishing, 1999.

Krishna 1971
Krishna, Anand, ed. *Chhavi: Golden Jubilee Volume, Bharat Kala Bhavan, 1920–1970.* Benares [Varanasi]: Benares Hindu University, 1971.

Latif, Schotsmans, and Nolens 1982

Latif, Momin, Jean-Pierre Schotsmans, and Leon
 Nolens. *Bijoux Moghols = Mogol Juwelen = Mughal
 Jewels*. Exh. cat. Brussels: Musées royaux
 d'art et d'histoire, 1982.

Markel 2004

Markel, Stephen. "Non-Imperial Sources for
 Jades and Jade Simulants in South Asia."
 Jewellery Studies 10 (2004), pp. 68–75.

Meen and Tushingham 1968

Meen, V. B., and A. D. Tushingham. *Crown Jewels of
 Iran*. Toronto: University of Toronto Press,
 1968.

Melikian-Chirvani 1986

Melikian-Chirvani, A. S. "State Inkwells in
 Islamic Iran." *The Journal of the Walters Art
 Gallery* 44 (1986), pp. 70–94.

Michell 2008

Michell, George. *The New Cambridge History of India,
 I/6; Architecture and Art of Southern India:
 Vijayamagara and the Successor States*. Cambridge:
 Cambridge University Press, 2008.

Moienuddin 2000

Moienuddin, Mohammad. *Sunset at Srirangapatam:
 After the Death of Tipu Sultan*. Hyderabad: Orient
 Longman, 2000.

Musta'id Khan 1947

Musta'id Khan, Muhammad Saki. *The Maasir-i'-
 Alamgiri: A History of the Emperor Aurangzib-
 'Alamgir (reign A.D. 1658–1707)*. Trans.
 Jadunath Sarkar. Calcutta: Royal Asiatic
 Society of Bengal, 1947.

Nadelhoffer 1984

Nadelhoffer, Hans. *Cartier: Jewelers Extraordinary*.
 New York: Harry N. Abrams, 1984.

Nandagopal and Iyengar 1995

Nandagopal, Choodamani, and Vatsala Iyengar.
 Temple Treasures. Bangalore: Crafts Council of
 Karnataka, 1995.

Nigam 1999

Nigam, Mohan Lal. *Indian Jewellery*. London: Tiger
 Books International, 1999.

Okada 2000

Okada, Amina. *L'Inde des princes: La donation Jean et
 Krishnâ Riboud*. Paris: Réunion des musées
 nationaux, 2000.

Pal 1989

Pal, Pratapaditya, et al. *Romance of the Taj Mahal*. Exh.
 cat. Los Angeles: Los Angeles County
 Museum of Art; London: Thames &
 Hudson, 1989.

Prior and Adamson 2000

Prior, Katherine, and John Adamson. *Maharajas'
 Jewels*. New York: Vendome Press, 2000.

Rana et al. 2003

Rana, Prabhakar S.J.B., et al. *The Ranas of Nepal*. New
 Delhi: Timeless Books, 2003.

Ricketts and Missillier 1988

Ricketts, Howard J., and Philippe Missillier.
 Splendeur des armes orientales. Exh. cat. Paris:
 Acte-Expo, 1988.

Roe 1899

Roe, Thomas. *The Embassy of Sir Thomas Roe to the
 Court of the Great Mogul, 1615–1619, as narrated in
 his journal and correspondence*. Ed. William
 Foster. London: Hakluyt Society, 1899.

Rudoe 1997

Rudoe, Judy. *Cartier: 1900–1939*. Exh. cat. New
 York: The Metropolitan Museum of Art,
 1997.

Salomé and Dalon 2013

Salomé, Laurent, and Laure Dalon. *Cartier: Style and
 History*. Exh. cat. Paris: Réunion des musées
 nationaux, 2013.

Sassoon and Rosenthal 2013

Sassoon, Adrian, and Joel A. Rosenthal. *Jewels by
 JAR*. New York: The Metropolitan Museum
 of Art, 2013.

Skelton et al. 1982

Skelton, Robert, et al. *The Indian Heritage: Court Life
 and Arts under Mughal Rule*. Exh. cat. London:
 Victoria and Albert Museum, 1982.

Stronge 1995
Stronge, Susan, ed. *The Jewels of India.* Bombay:
 Marg Publications, 1995.

Stronge 2009
Stronge, Susan. *Tipu's Tigers.* London: V&A
 Publishing, 2009.

Stronge, Poovaya-Smith, and Harle 1988
Stronge, Susan, Nima Poovaya-Smith, and James
 C. Harle. *A Golden Treasury: Jewellery from the
 Indian Subcontinent.* Exh. cat. New York: Rizzoli,
 in association with the Victoria and Albert
 Museum and Grantha Corporation, 1988.

Tait 1986
Tait, Hugh. *Catalogue of the Waddesdon Bequest in the
 British Museum: I. The Jewels.* London: British
 Museum, 1986.

Teng Shu-p'ing 2004
Teng Shu-p'ing. "On the Eastward Transmission
 of Islamic-Style Jades during the Ch'ien-
 lung and Chia-ch'ing Reigns." *National Palace
 Museum Bulletin* 37, no. 2 (September 2004).

Teng Shu-p'ing 2012
Teng Shu-p'ing. *Exquisite Beauty: Islamic Jades.* Taipei:
 National Palace Museum, 2012.

Tipu Sultan n.d.
Tipu Sultan. *The Dreams of Tipu Sultan.* Trans.
 Mahmud Husain. Karachi: Times Press, n.d.

Untracht 1997
Untracht, Oppi. *Traditional Jewelry of India.* New
 York: Harry N. Abrams, 1997.

Vernoit 1997
Vernoit, Stephen. *Occidentalism: Islamic Art in the 19th
 Century.* London: Nour Foundation, 1997.

Watt 1903
Watt, George. *Indian Art at Delhi, 1903: Being the
 Official Catalogue of the Delhi Exhibition,
 1902–1903.* Calcutta: Superintendent of
 Government Printing, 1903.

Welch 1985
Welch, Stuart Cary. *India: Art and Culture,
 1300–1900.* Exh. cat. New York: The
 Metropolitan Museum of Art, 1985.

Wild 1934
Wild, Roland. *The Biography of Colonel His Highness
 Shri Sir Ranjitsinhji Vibhaji, Maharaja Jam Saheb of
 Nawanagar, G.C.S.I., G.B.E., K.C.I.E.* London:
 Rich & Cowan, 1934.

Wright 2008
Wright, Elaine. *Muraqqa': Imperial Mughal Albums from
 the Chester Beatty Library, Dublin.* Exh. cat.
 Alexandria, Va.: Art Services International,
 2008.

Zebrowski 1983
Zebrowski, Mark. *Deccani Painting.* London:
 Sotheby Publications; Berkeley: University
 of California Press, 1983.

Zebrowski 1997
Zebrowski, Mark. *Gold, Silver and Bronze from Mughal
 India.* London: Alexandria Press, in associa-
 tion with Laurence King, 1997.

Zucker 2000
Zucker, Benjamin. *Blue: A Novel.* Woodstock, N.Y.:
 Overlook Press, 2000.

Zucker 2002
Zucker, Benjamin. *Green: A Novel.* New York:
 Overlook Press, 2002.

Auction Catalogues
Bonhams 2009
*Islamic and Indian Art, Lot 212; An Important and
 Previously Unrecorded Gem-Set Gold Finial from the
 Throne of Tipu Sultan, The Tiger of Mysore: Thursday
 2 April 2009.* London: Bonhams, 2009.

Bonhams 2011
Islamic and Indian Art: Tuesday 4 October 2011. London:
 Bonhams, 2011.

Christie, Manson & Woods 1989
*Indian, Himalayan and South East Asian Miniatures and
 Works of Art from Various Sources: Tuesday 10
 October 1989.* London: Christie, Manson &
 Woods, 1989.

Christie's Geneva 2000
Magnificent Jewels: 17 May 2000. Geneva: Christie's,
 2000.

Christie's Geneva 2009
Jewels; The Geneva Sale: 18 November 2009. Geneva:
 Christie's, 2009.

Christie's Geneva 2010
The Geneva Sale; Jewels: Wednesday 17 November 2010.
 Geneva: Christie's, 2010.

Christie's London 1997
Important Indian Jewellery: Wednesday 8 October 1997.
 London: Christie's, 1997.

Christie's London 1999
Magnificent Mughal Jewels: Wednesday 6 October 1999.
 London: Christie's, 1999.

Christie's London 2005
Arts of India: Friday 23 September 2005. London:
 Christie's, 2005.

Christie's London 2010
*Art of the Islamic and Indian Worlds, Including Art from the
 Collection of Dr. Mohammed Said Farsi: Tuesday 5
 October 2010.* London: Christie's, 2010.

Christie's London 2012
Art of the Islamic and Indian Worlds: 26 April 2012.
 London: Christie's, 2012.

Christie's New York 2009
*Rare Jewels and Objets d'Art; A Superb Collection: Wednesday
 21 October 2009.* New York: Christie's, 2009.

Christie's New York 2010
*Jewels; The New York Sale with the Catherine the Great
 Emerald Brooch and the Emperor Maximilian Diamond:
 22 April 2010.* New York: Christie's, 2010.

Elliott and Snowden 1974
Autumn Exhibition of Arms and Armour. London: Elliott
 and Snowden, 1974.

Habsburg Feldman 1987
*Islamic and Indian Treasures and Jewels/Trésors et Bijoux
 Islamiques et Indiens.* Geneva: Habsburg
 Feldman, 1987.

Simon Ray 2009
*Indian and Islamic Works of Art: Monday 26th October
 2009 to Monday 30th November 2009.* London:
 Simon Ray, 2009.

Sotheby's London 2005
*Exotica; East Meets West 1500–1900: Wednesday 25 May
 2005.* London: Sotheby's, 2005.

Sotheby's London 2008
*Art of the Islamic World, Including Fine Carpets and
 Textiles: 8 October 2008.* London: Sotheby's,
 2008.

Sotheby's London 2010
*Arts of the Islamic World, Including Fine Carpets and
 Textiles: Wednesday 14 April 2010.* London:
 Sotheby's, 2010.

Sotheby's New York 2010
Arts of the Islamic World: 9 December 2010. New York:
 Sotheby's, 2010.

Sotheby's New York 2012
Magnificent Jewels: 18 April 2012. New York:
 Sotheby's, 2012.

ACKNOWLEDGMENTS

We would like to thank His Highness Sheikh Hamad bin Abdullah Al-Thani for generously sharing this collection and for encouraging the scholarly study of it. Amin Jaffer has been a creative and curatorial partner in putting together this project, for which special acknowledgment is due. We are grateful to the scholarly team that contributed to *Beyond Extravagance: A Royal Collection of Gems and Jewels*, the publication of the Al-Thani collection upon which this present volume relies, including its editor, Amin Jaffer, and the other authors: Michael Spink, Robert Skelton, Jack Ogden, Stephen Vernoit, Katherine Prior, Judy Rudoe, and Vivienne Becker. Susan Stronge of the Victoria and Albert Museum also provided much scholarly help.

At the Metropolitan Museum, we thank Thomas P. Campbell, Director; Emily Kernan Rafferty, President; Jennifer Russell, Associate Director for Exhibitions; and Sheila R. Canby, Patti Cadby Birch Curator in Charge, Department of Islamic Art. Special thanks are due to Courtney Ann Stewart, Senior Research Assistant in the Department of Islamic Art, for her collaboration on this project. We also owe our gratitude to the Registrar's Office (Aileen Chuk), the Exhibitions Office (Martha Deese, Linda Sylling, and Maria E. Fillas), the Office of the Senior Vice President, Secretary, and General Counsel (Sharon H. Cott and Amy D. Lamberti), the Communications Office (Elyse Topalian and Egle Žygas), and the Development Office (Nina McN. Diefenbach and her colleagues). We extend our appreciation to colleagues in the Departments of Islamic Art and Asian Art, as well as Lisa Pilosi, Sherman Fairchild Conservator in Charge, Department of Objects Conservation, and her colleagues Jean-François de Lapérouse and Frederick J. Sager.

For this publication we are grateful to our colleagues in the Editorial Department, particularly Elisa Urbanelli and Sally VanDevanter, as well as Mark Polizzotti, Gwen Roginsky, Peter Antony, Michael Sittenfeld, Jane S. Tai, Crystal A. Dombrow, Elizabeth Zechella, and Pamela T. Barr. We also thank Jean Wilcox for her design of the book and Prudence Cuming Associates for the photography of the collection objects.

Our colleagues in the Design Department—Michael Batista, Sophia Geronimus, Clint Ross Coller, Richard Lichte, and Susan Sellers—deserve thanks for their role in mounting this exhibition. Taylor Miller in the Buildings Department helped with the installation.

Several individuals in India were helpful to this project. Pramod Kumar KG helped source pictures and Usha Bala Krishnan provided general information about the history of objects. For the use of their photographs in the installation

and publication, we are appreciative to the descendants of the royal families and others depicted.

In addition to lending support for the exhibition, Cartier generously helped with archival research, particularly Gaëlle Naegellen in Paris. We also thank Terence McInerney and Benjamin Zucker for their advice and Francesca Galloway, Sam Fogg, Simon Ray, Samina Khanyari, and Howard Ricketts for their assistance with object information.

Navina Najat Haidar
Curator, Department of Islamic Art
The Metropolitan Museum of Art

INDEX

Page numbers in *italics* refer to illustrations.

PHOTOGRAPH CREDITS

Photographs of objects from the Al-Thani Collection are by Prudence Cuming Associates, Ltd., London

Figs. 2–3 and pp. 29, 32, 35, 86, 89: Royal Collection Trust / © Her Majesty Queen Elizabeth II 2014; fig. 4 and pp. 106, 109 top, 113: Archives Cartier Paris © Cartier; fig. 6: Prior and Adamson 2000, p. 26; fig. 27 and pp. 68, 72: © Victoria and Albert Museum, London; p. 46: © National Trust (photograph by Kate Lynch); p. 53: Topsfield, Andrew. *Court Painting at Udaipur: Art Under the Patronage of the Maharanas of Mewar.* Zurich: 2001, p. 160; p. 59: Jaffer 2013, p. 75; p. 61 bottom: © National Trust Images (photograph by Clare Bates); p. 62: Foto Crafts, the Deen Dayal Studio, Hyderabad (photograph by Vikas C. Jain); p. 69: The David Collection, Copenhagen (photograph by Pernille Klemp); p. 82: © Maharana of Mewar Charitable Foundation, Udaipur; p. 94: Rana et al. 2003, p. 109; p. 101: © 2014 Artists Rights Society (ARS), New York / ADAGP, Paris; p. 105: Hillwood Estate, Museum, and Gardens (Photograph by Brian Searby); p. 109, bottom: © National Portrait Gallery, London; p. 117: © Christie's Images / The Bridgeman Art Library; p. 118: Photograph © Antonio Martinelli; p. 120: Deen Dayal, Raja, and Clark Worswick. *Princely India: Photographs by Raja Deen Dayal, 1884–1910.* New York: 1980, p. 47